IMAGES
of Modern America

HUDSON

On the Front Cover: Pictured clockwise from the top left: Morgan Hall (Courtesy of Western Reserve Academy; see page 15), Hudson High School Swing Marching Band on Lavelli Field (Author's collection; see page 93), Main Street (Courtesy of Hudson Library and Historical Society; see page 81), 1976 bicentennial celebration (Courtesy of Patricia S. Eldredge; see page 64), Old Church on the Green (Courtesy of Hudson Library and Historical Society; see page 20)

On the Back Cover: Pictured clockwise from the top left: Fire department Jeep at ice-cream social (Courtesy of Hudson Library and Historical Society; see page 87), children's librarian Marjie Origlio with young reader (Courtesy of Hudson Library and Historical Society; see page 63), group in front of clock tower (Courtesy of Hudson Library and Historical Society; see page 66)

IMAGES
of Modern America

HUDSON

Jill A. Grunenwald

ARCADIA
PUBLISHING

Published by Arcadia Publishing
Charleston, South Carolina

Printed in the United States of America

Library of Congress Control Number: 2014958789

For all general information, please contact Arcadia Publishing:
Telephone 843-853-2070
Fax 843-853-0044
E-mail sales@arcadiapublishing.com
For customer service and orders:
Toll-Free 1-888-313-2665

Visit us on the Internet at www.arcadiapublishing.com

*For my family, who have never once doubted
that someday I would publish a book.*

CONTENTS

ACKNOWLEDGMENTS

I graduated from Hudson High School in 2000 as a member of the Thirteen Year Club, a select group of students in each graduating class who spent their kindergarten through 12th-grade years in the Hudson City Schools. Like many of my generation, all I wanted to do was escape the picturesque hamlet for far more cosmopolitan scenery. I finally did in 2006, but personal circumstances made for a return to Northeast Ohio in 2009. Since returning, I have witnessed many of my peers making the same pilgrimage, we the native sons and daughters of David Hudson. It is as if we needed to leave to really see all that we left behind.

I truly would not have been able to start, let alone finish, this book were it not for all the people who assisted me along the way. Some offered photographs and information while others offered support and encouragement; but, each in his own turn helped me rediscover a love for the town that raised me, and for that I am forever grateful. Honorable mentions go to Bill Barrow, Barbara Bos, Amy and AJ Burke, Jennifer Coppolo Holsing, Bennett Cowie, Ben Cox, Steve Dulzer, Patricia S. Eldredge, Adam Fishman, Regan Gettens, Cameron Holloway, Frank Manak, Liz Murphy, Jeannette Palsa, Kerry W. Paluscsak, Connie Price, Ms. Ren, Denise Ruffing, Tracy Schooner, Sheryl Sheatzley, and Jimmy Sutphin.

Many thanks go to everyone at Arcadia, but especially my acquisitions editors Julia Simpson and Betsey Poore. Julia helped this author navigate her first book, and it was Betsey who first suggested writing something for the Images of Modern America series as soon as I mentioned my hometown. I am also eternally indebted to archivist extraordinaire Gwendolyn Mayer at the Hudson Library and Historical Society for opening the archives to this former page. I sincerely would not have been able to complete this project without her.

In August 1981, a young couple moved to the cozy community of Hudson in anticipation of the birth of their first daughter. For that, all I can say is thanks, Mom and Dad.

INTRODUCTION

In July 1976, Hudson, along with the rest of the country, participated in recognizing the nation's 200th birthday with a community-wide celebration. Along with a parade that traveled down Main Street, residents also gathered for festivities on the town square, known colloquially as the Green. This was not the first time for such a gathering; in fact, this small patch of green space downtown has hosted moments of town revelry for over a century.

In the decade following the infamous 1892 fire that devastated Main Street, residents continued to struggle, so in 1906, community leaders decided to host a Home Day, developed as a means of boosting civic pride. Former Hudsonites were encouraged to return to join in the celebration of the town's founding. That first year, 500 people registered, and the event was so successful, a second Home Day was held in 1907. It was around this time that millionaire and native son James W. Ellsworth returned, and through his financial aid, Hudson began to not only recover but prosper. His most recognizable contribution is the 1912 iconic clock tower that sits on the north end of the Green.

Since then, the Green has become the location for the annual ice-cream social, a fine-arts and crafts show, a farmers' market, and a summer concert series. But, the US bicentennial is particularly noteworthy because the town was also celebrating the new gazebo-style bandstand. Today, the bandstand is a community fixture, but in 1976, the structure was still brand new, built especially for the bicentennial. Though the current bandstand is Hudson's third, it was built in a gazebo style similar to that of the 1880 original. This effort to preserve the past while forging ahead into the future is the legacy on which Hudson is proudly built.

As far as cities go, Hudson is still relatively young. While founded in 1799 by David Hudson as part of the Connecticut Western Reserve, the community did not officially become a city until after the 1990 census, with the proclamation coming from the Ohio secretary of state in March 1991. Even then, for the next couple of years it actually existed as two separate entities; there was the city of Hudson Village and also Hudson Township. The township was the smaller of the two, comprising most of the downtown historic district with the village surrounding it. At the November 1993 election, it was put to a vote, with residents voting to merge, and the merger of the two entities became official on January 1, 1994.

The town's steady rise in population can be traced back to the opening of the Ohio Turnpike in 1955, which brought greater opportunities for travel across the United States. Suddenly, this sleepy little community in Northeast Ohio, with its picturesque downtown square and thriving school district, soon became an ideal home base for commuters. As these postwar families moved in during the late 1950s and early 1960s, it soon became necessary to expand academically as baby boomer students outgrew the classrooms. In time, three new school buildings were introduced into the district: Evamere Elementary, East Woods Elementary, and McDowell Elementary. In the early 1990s, it became necessary to expand again, and when the current high school was opened in 1992, the former high school was turned into the middle school. Even with the city's

concentrated historic preservation efforts, not all buildings were able to withstand the test of time, and Hudson Elementary was torn down in 2010, five years shy of its 100th birthday.

While education has always played a vital role in Hudson's history, Hudson has equally made a mark on the educational history of the nation. Western Reserve Academy, a coeducational boarding school, opened in 1826 as Western Reserve College and Preparatory School. At the time, it was known as the Yale of the West, and in 1882 the college migrated to Cleveland, where it eventually became Case Western Reserve University. The academy continued to operate until 1903, when financial constraints forced it to close, but it was able to reopen in 1916 under the assistance of James W. Ellsworth. While the school had always operated as coeducational up to this point, in 1922 the school's trustees decided to stop accepting applications from girls. The school continued to operate as an all-boys institution until 1972, at which point girls were once again allowed to apply for admittance.

The Hudson City Schools and Western Reserve Academy are the two largest educational organizations within the city, but several independent schools do exist, including Hudson Montessori. Dating back to 1962, Hudson Montessori School is the 13th-oldest Montessori school in the nation.

Hudson has always supported local commerce, often coming in the form of independent stores and businesses. There is so much support that, aesthetically, little of Main Street has changed since the city's founding. Not only have many of the shops been in business for multiple decades, but when a new shop takes over a space, little is changed of the outside or inside. As far as new business goes, one only needs to walk down a block to reach First & Main, a mixed-use retail plaza that was erected in 2004. Built behind the Main Street shops on land originally owned by the Morse Controls Company, the exterior of First & Main blends seamlessly with the older architecture nearby. Hudson also made history in 2002 when it launched what is believed to be the very first citywide electronic gift card available in the United States.

Most of Ellsworth's contributions to the community are visual in nature: the Colonial-style homes that have stood for over a century, the elm trees that line the city streets, even the red tiles that were offered free of charge to those residents willing to reroof. But more than anything else, Ellsworth instilled a sense of history and pride. Upon his return, it perhaps would have been easier to raze and rebuild, but instead, he opted to reinstate and restore. Aided by his work and legacy, the town continues to preserve its history, and its own work has been rewarded by the National Register of Historic Places, which first listed the Hudson Historic District in 1973, with an expansion of the district awarded in 1989.

One

EDUCATION AND RELIGION

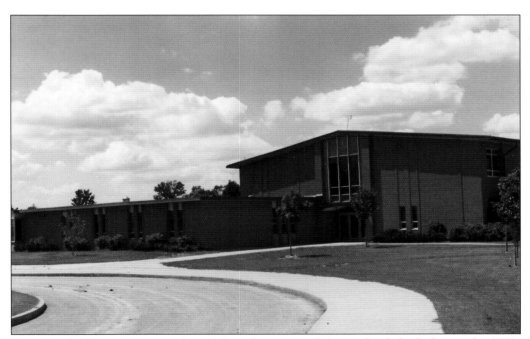

East Woods Elementary opened in 1962 and was one of three schools built during the 1950s and 1960s in response to Hudson's rapidly growing population. The other two schools were Evamere Elementary (1958) and McDowell Elementary (1967). (Courtesy of Hudson Library and Historical Society.)

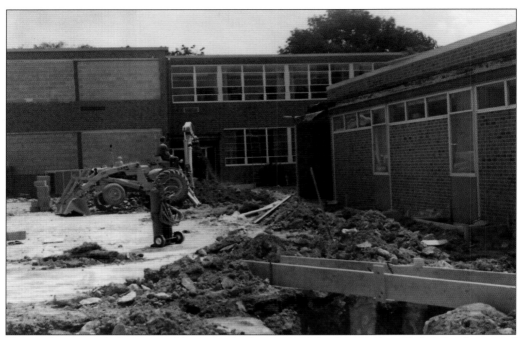

During the summer of 1971, an addition was built to expand the then Hudson High School, pictured here during the construction phase. In 1922, when the Western Reserve Academy no longer admitted girls, many of whom were Hudson residents, the Hudson Board of Education initiated plans to build Hudson High School on Oviatt Street. When the current high school was built in 1992, this building became the middle school. Every day, hundreds of sixth, seventh, and eighth graders pass through its halls. (Both, courtesy of Hudson Library and Historical Society.)

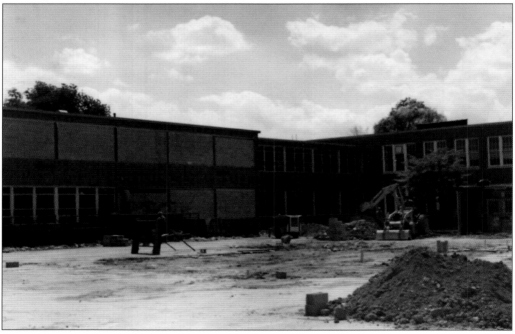

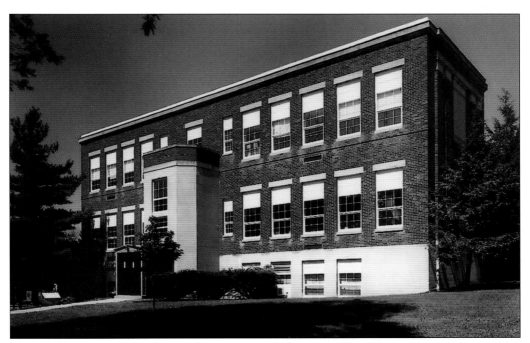

Hudson Elementary School opened in 1915 and was often called the Oviatt School due to its location on Oviatt Street. The nearly 100-year-old building was torn down in 2010, and the empty lot was converted into a park owned by the school district. (Courtesy of Hudson City Schools.)

HUDSON HIGH SCHOOL
ONE HUNDRED FIFTEENTH
ANNUAL COMMENCEMENT

E.J. THOMAS PERFORMING ARTS HALL
THE UNIVERSITY OF AKRON
AKRON, OHIO

JUNE SEVENTH, TWO THOUSAND

The Explorers emblem that represents the Hudson City School District, as well as the school colors of blue and white, were implemented in 1928 when the Hudson High School on Oviatt Street opened. Of the 384 students that made up the class of 2014, ninety-three percent were college-bound. (Author's collection.)

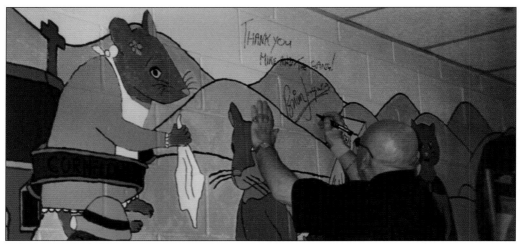

When British children's fantasy author Brian Jacques came to the United States on a book tour in 2005, one of his stops included Hudson. Here, he is seen signing a mural at Hudson Middle School that was created by a class led by teacher Michael Fejes. (Courtesy of Liz Murphy.)

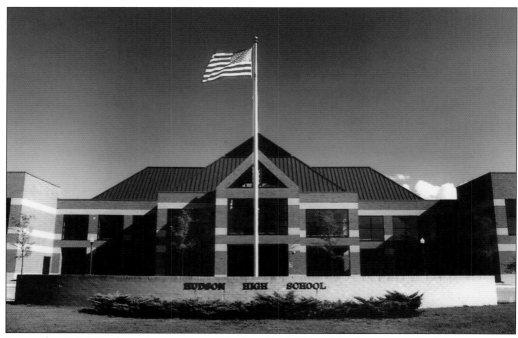

Located at 2500 Hudson-Aurora Drive, Hudson High School is the center of a 72-acre campus that includes multiple athletic facilities. In 1992, the 300,000-square-foot building opened at a cost of $24 million. Built in such a way to allow for growth, the west side of the building was expanded for the 2006–2007 school year. (Courtesy of Hudson City Schools.)

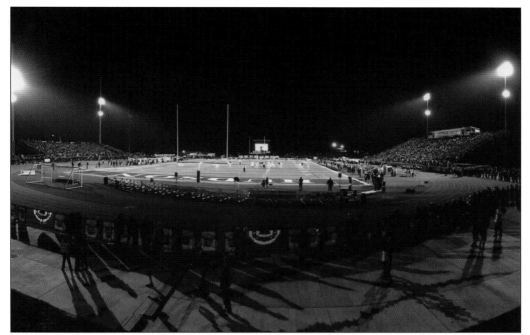

Built to replace Lavelli Field, Hudson Memorial Stadium was a $5.5-million project completely funded by the community. The complex includes a track, all-weather turf, and seating for 5,000. In 2014, the Hudson Explorers varsity football team had its best winning record in its entire 95-year history, making it all the way to the regional finals. (Courtesy of Kerry W. Paluscsak.)

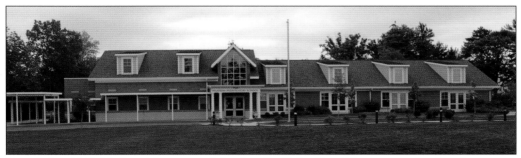

Founded in 1962, Hudson Montessori School is the 13th-oldest Montessori school in the nation. Originally, classes were held in a one-room schoolhouse in downtown Hudson, but in 1968 the founders purchased land on Darrow Road as a new home for their permanent building. (Courtesy of Hudson Montessori School.)

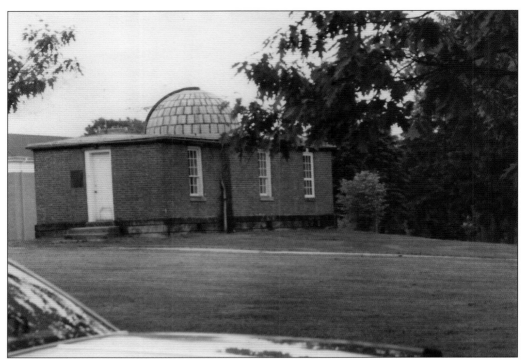

Western Reserve Academy's Loomis Observatory was built in 1838 and is one of the oldest observatories still standing in the country. While no longer operational, much of the original astronomical equipment remains intact, including the Troughton and Simms telescope. (Courtesy of Hudson Library and Historical Society.)

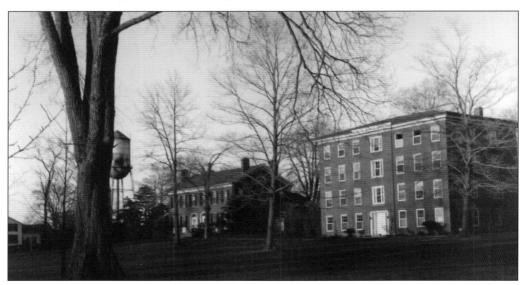

The president's house (left) and North Hall (right) are both part of Western Reserve Academy's historic Brick Row. North Hall opened as a dormitory in 1838 when Western Reserve Academy was still a university. Originally, the residence hall was to be called Theological Hall, as it was intended for divinity students. (Courtesy of Hudson Library and Historical Society.)

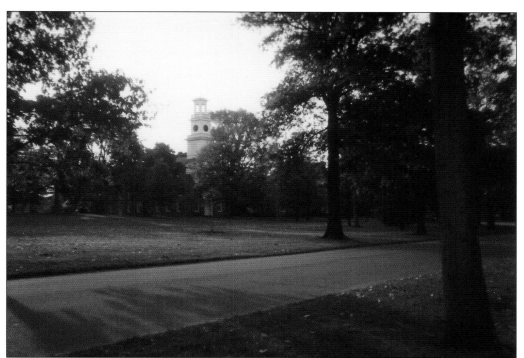

Several of the illustrious buildings that make up Western Reserve Academy's Brick Row are visible in this photograph, including the chapel, which is the backdrop for commencement ceremonies. The location comes with a long history, and in 1854 the commencement address was delivered by abolitionist Frederick Douglass. (Courtesy of Hudson Library and Historical Society.)

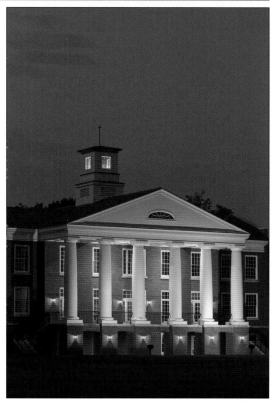

Sitting on the western side of Western Reserve Academy's campus is the breathtaking Morgan Hall. Funded by a grant from local philanthropist Burton D. Morgan and his foundation, it was completed in 2004 and houses several educational departments, including the health center and head of school. (Courtesy of Western Reserve Academy.)

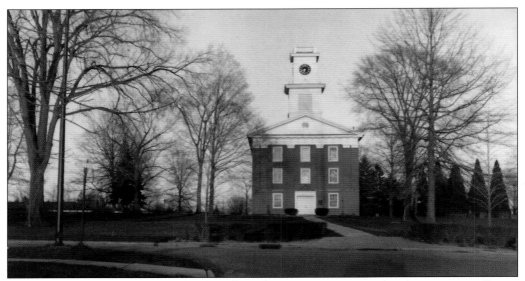

This 1970s photograph shows the chapel on the Western Reserve Academy campus. It was during this progressive era in American history that Western Reserve Academy broke a 50-year all-male tradition by introducing girls into the junior class, once again becoming a coeducational institution. (Courtesy of Hudson Library and Historical Society.)

This view of a tree-lined Chapel Street looks toward the chapel on the Western Reserve Academy campus. Reserve is the oldest preparatory boarding school outside of the Northeast and the 27th-oldest in the country. It is also one of the few boarding schools that continues to require a dress code. (Courtesy of Hudson Library and Historical Society.)

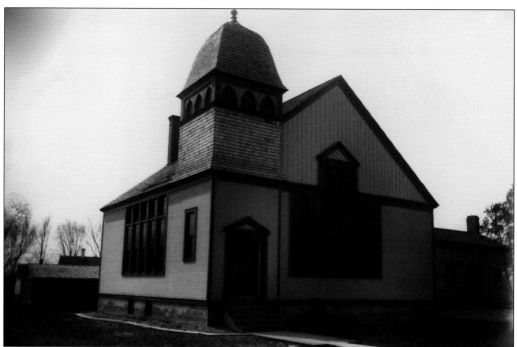

This edifice at 50 Division Street has spent much of its life as a house of worship. Dedicated in 1892 as the home of Disciples of Christ, also known as First Christian Church, the site is now home to Temple Beth Shalom. On April 20, 1860, before the church was officially founded, future US president James A. Garfield spoke there. (Courtesy of Hudson Library and Historical Society.)

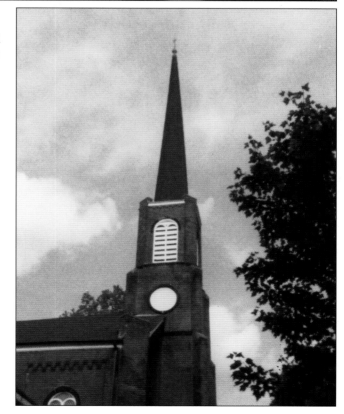

The First Congregational Church was the first church built in Hudson, and it held its first service in 1800. Over the years, the congregation has met in several locations in town, and the sanctuary of the current facility was constructed in 1865. (Courtesy of Hudson Library and Historical Society.)

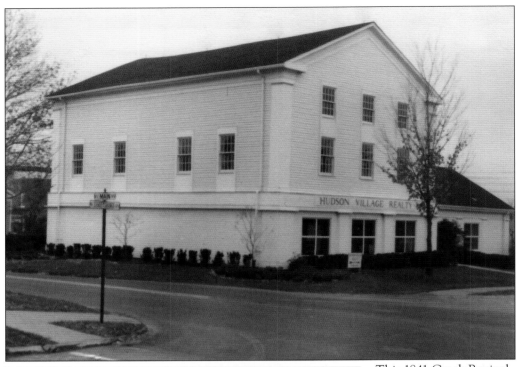

This 1841 Greek Revival was originally a one-story building and the location of Hudson's Free Congregational Church, first established by resident Owen Brown, father of John Brown. It now operates as a commercial building. (Courtesy of Hudson Library and Historical Society.)

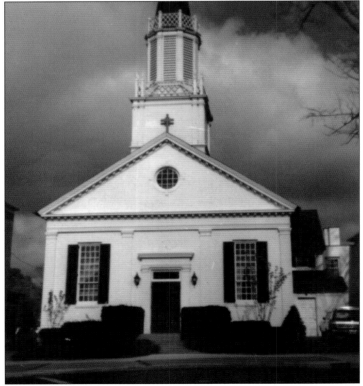

Christ Church Episcopal of Hudson was created in 1842 under the direction of local merchant Anson A. Brewster. The current church building was built in 1930, replacing the original wooden Gothic chapel that was built in 1846. (Courtesy of Hudson Library and Historical Society.)

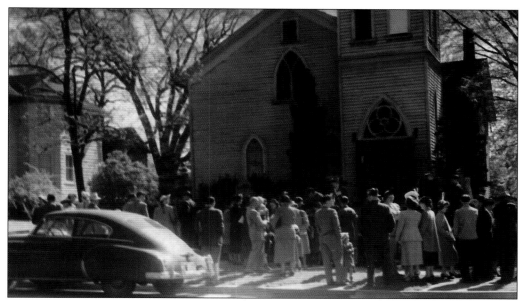

Parishioners gather outside of St. Mary's after Sunday mass. The Old Church on the Green was used by the Roman Catholic congregation from 1890 until 1973, at which point it moved to its current home on the north side of town near the campus of Western Reserve Academy. (Courtesy of Hudson Library and Historical Society.)

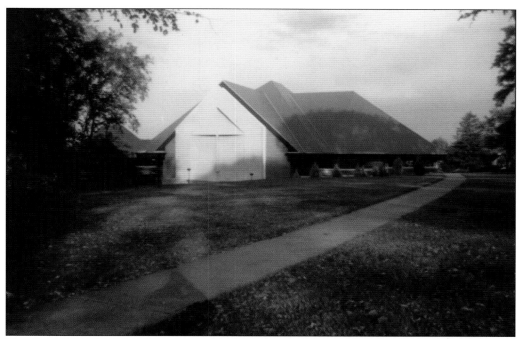

The Roman Catholic congregation of St. Mary's was first established in Hudson in 1847 and spent nearly 80 years at 1 East Main Street before moving to this modern building in 1973. In September 2009, an outdoor grotto on the east side of the church was dedicated. (Courtesy of Hudson Library and Historical Society.)

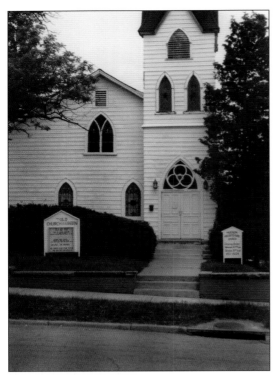

As its name suggests, the Old Church on the Green sits on the town square in downtown Hudson. Built in 1860, the church became the home of the St. Mary's Parish in 1890, and services were held there until they moved to their current home on North Main Street in 1973. Since then, the Old Church on the Green has served as a temporary home for Temple Beth Shalom and currently houses the Spiritual Life Society. (Both, courtesy of Hudson Library and Historical Society.)

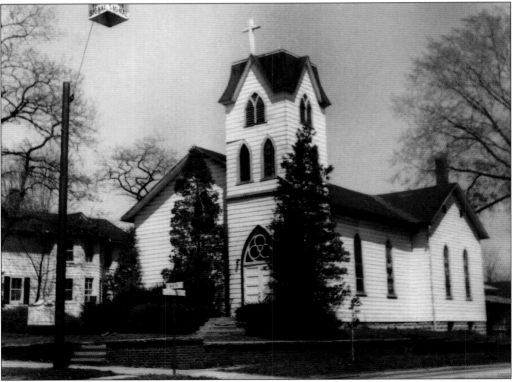

The cornerstone of Gloria Dei Lutheran Church was laid in 1968, on 14 acres of Ravenna Street property owned by the Missouri Synod. For economic reasons, volunteers assisted on much of the interior. Two decades later, a $500,000 expansion doubled the size of the physical building and allowed for the creation of a preschool. (Courtesy of J. Palsa Photography.)

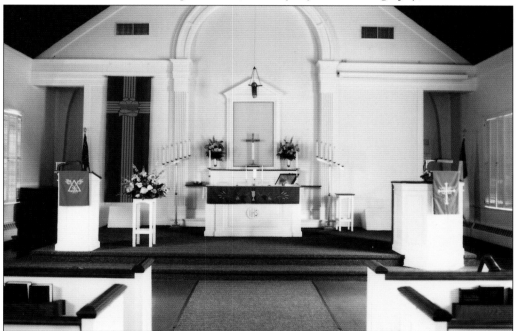

After spending two years meeting at Evamere Elementary, Gloria Dei Lutheran Church had its first service in its own sanctuary on May 4, 1969. At that time, there were 180 baptized members, but the congregation continued to grow; by the time of the 10-year anniversary in 1977, there were already 100 families. (Courtesy of J. Palsa Photography.)

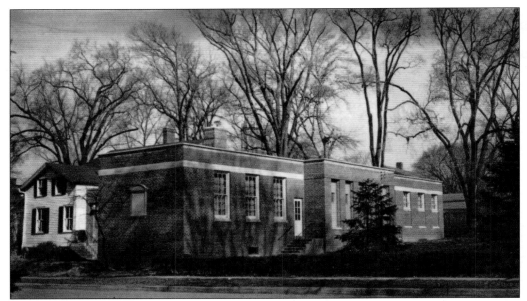

During the 1950s, a $90,000 new wing was built onto the Hudson Library and Historical Society. The addition, which opened in May 1954, is seen here before it was painted. This addition made room for shelving, a reading room, and a special space for a museum and exhibits. (Courtesy of Hudson Library and Historical Society.)

Seen here is a book display in the former building of the Hudson Library and Historical Society. The library called its location on Aurora Street home from 1924 until 2005, at which point it moved into its current home as part of the First & Main shopping plaza. (Courtesy of Hudson Library and Historical Society.)

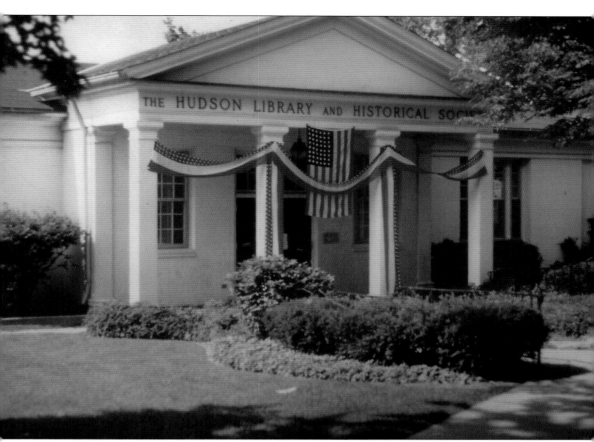

During the 1960s, the Hudson Library and Historical Society constructed a new addition to the existing building and celebrated its first 50 years with a golden-year recognition. Part of the celebration included commemorative plates, which were available for purchase. (Courtesy of Hudson Library and Historical Society.)

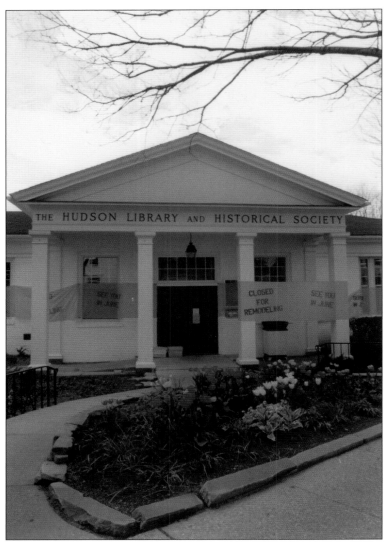

When the Hudson Library and Historical Society was renovated in 1995, the building was closed for a month. During this time, residents were encouraged to check out as many books as they wanted to limit the number of books on the shelves during the renovation. (Courtesy of Hudson Library and Historical Society.)

On June 11, 2005, the brand-new Hudson Library and Historical Society building opened its doors to 8,500 visitors. Built as part of the First & Main shopping plaza, the library has been recognized by the American Library Association as a 5-Star Library. (Courtesy of Hudson Library and Historical Society.)

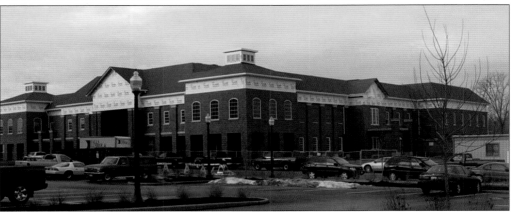

Two

BUSINESS AND INDUSTRY

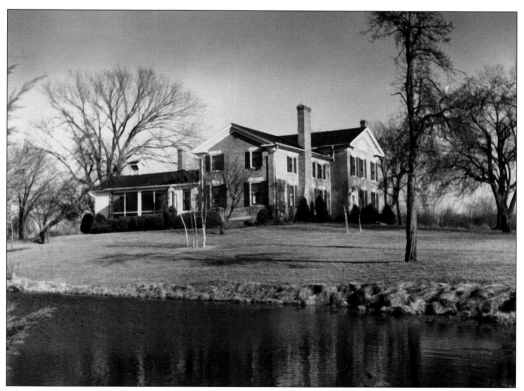

The Flood Company was a family-owned business founded in 1841 that had its corporate headquarters in Hudson. A leading producer of wood-stain and paint-additive solutions for commercial and consumer use, the company was sold in recent years, and its facilities moved to Strongsville, Ohio. (Courtesy of Hudson Library and Historical Society.)

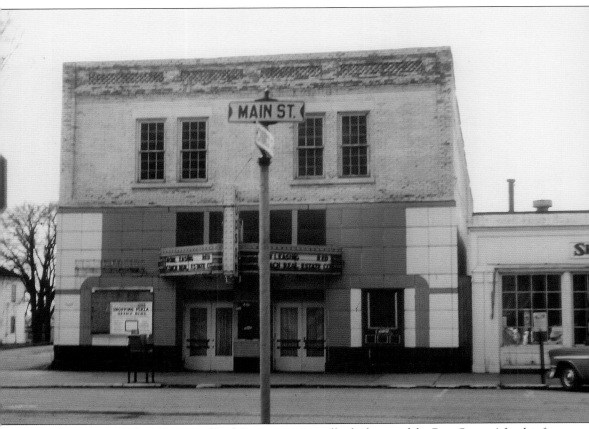

The corner of Main Street and Park Lane was originally the home of the Buss Store. After his first store burned down in the fire of 1892, Charles Buss rebuilt the business on the same site. During the 1930s, the building sat empty and abandoned and was considered a blight on the otherwise picturesque downtown landscape, so in 1940 the space was remodeled to become the Hudson Theater. The 442-seat movie theater opened its doors on May 4, 1941, and continued to show films for the next 20 years, before closing in the early 1960s. After the structure was torn down, that corner on the southern end of Main Street soon became the site of the Hudson Square Building. The current Hudson movie theater, located on the southern end of town near the Stow border, opened in the mid-1990s. (Courtesy of Hudson Library and Historical Society.)

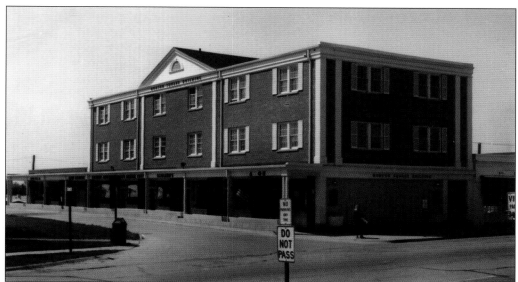

Hudson Square Building is a mixed-use structure right on the corner of North Main Street and Streetsboro Road, right across the street from the Green. The two-story edifice anchors the southern end of the Main Street stores and has always been home to multiple retail stores and other local businesses. Built in 1962, it is located on the former site of the Hudson Theater. Despite being one of the more recent buildings on the block, it still fits in with the older original facades that have been in existence since the early 1900s. (Both, courtesy of Hudson Library and Historical Society.)

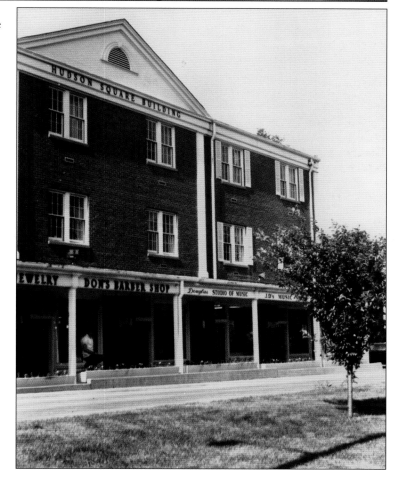

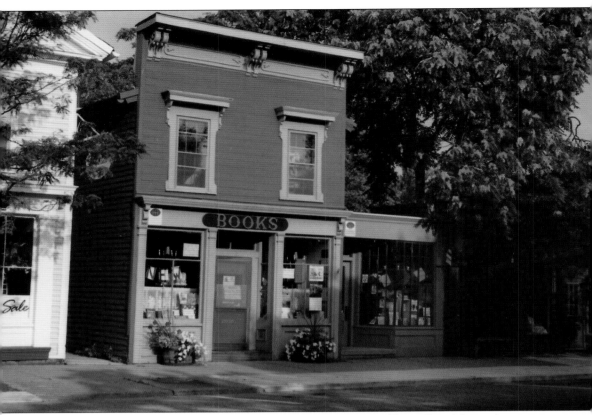

The buildings at 202 and 204 North Main Street were constructed by William Noonan, a carpenter who also did the cabinetry work in the Old Church on the Green. Noonan used the southern building for his shop while the attached northern building was utilized by his brother John, a shoemaker. In 1968, Jean and Bob Isabel purchased the northern side and founded the Learned Owl Book Shop. In the mid-1970s, the southern side of the building was purchased and the store expanded, doubling the shop's size. Today, the Learned Owl is comprised of 2,300 square feet spread out over three floors. (Courtesy of Liz Murphy.)

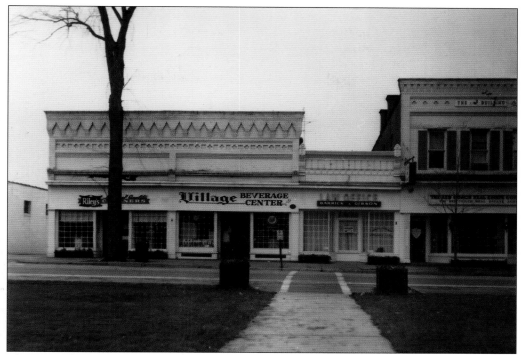

This 1967 photograph from the Green shows several Hudson businesses at the time; from left to right are Riley's Cleaners, Village Beverage Center, the Law Offices of Barrick & Gibson, and the Red Coach Real Estate Company. Riley's is still a fixture along Main Street, although it is now located one door down. (Courtesy of Hudson Library and Historical Society.)

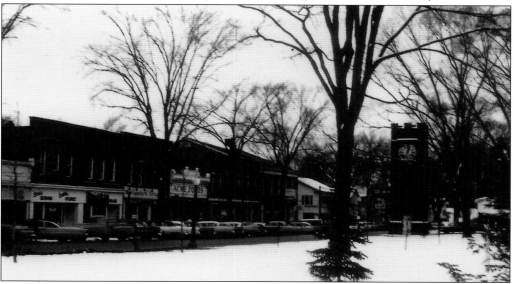

Through the gray winter landscape, the neon-red sign of Hudson's iconic Saywell's Drug Store beckons. From 1909 until it closed in 2005, Saywell's was a combination pharmacy and soda fountain. In later years, it was a favorite postgame ice-cream spot for Hudson's Little League teams. (Courtesy of Hudson Library and Historical Society.)

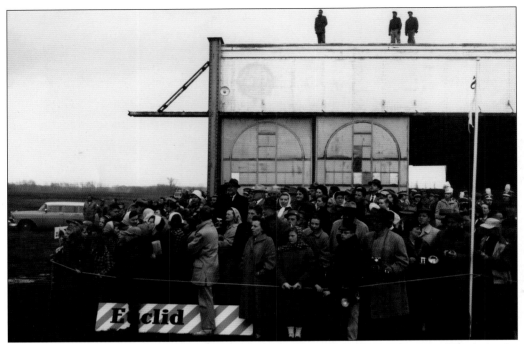

Part of Hudson's rapid population growth in the 1950s and 1960s can be traced back to the introduction of the Euclid Plant, a new factory that operated under the Euclid Division of General Motors Company. Some residents were concerned about the impact the industrial changes would make to the town, and a five-person Hudson Development Committee was created to oversee a land-use survey. In the end, the committee opted to stay neutral on the topic of the Euclid Plant, and construction on the factory began. The land is now home to the corporate headquarters of Jo-Ann Fabrics. (Both, courtesy of Hudson Library and Historical Society.)

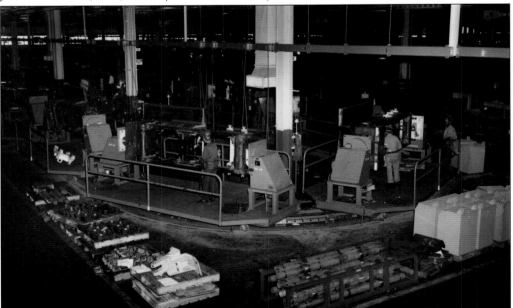

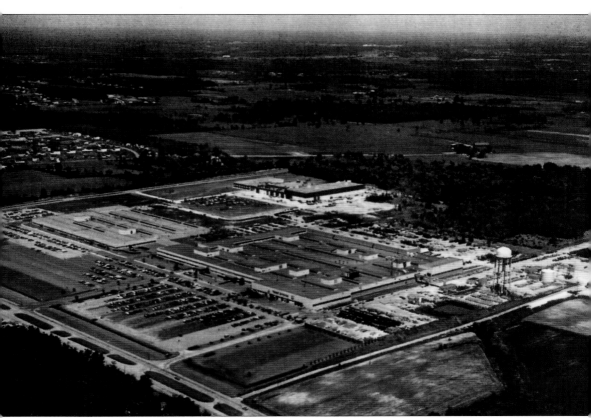

Pictured here is an aerial view of the factory owned and operated by General Motors Company. Originally the Euclid Plant, the factory required a name change following a 1968 federal antitrust suit. Terex came from *terra* (earth) and *rex* (king). Before the factory was built in the late 1950s, this land was the site of the Issoden Mid-City Airport. (Courtesy of Hudson Library and Historical Society.)

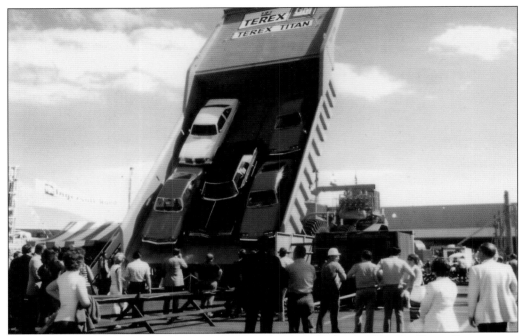

The Terex Titan was an off-highway powertrain haul truck designed by the Terex Corporation and assembled in 1973. At the time it was introduced, the Titan was the largest haul truck in the world. Only one prototype was ever made, and it is currently on display in British Columbia, Canada. (Courtesy of Hudson Library and Historical Society.)

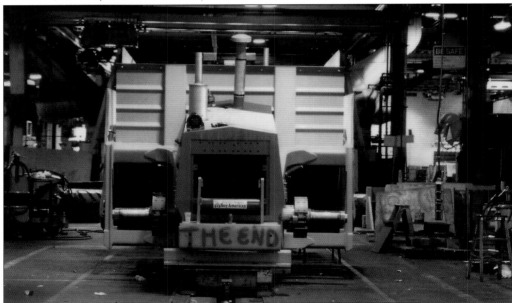

Pictured here is the last Terex TS-14B produced at the Hudson Plant as it rolls off the assembly line in the summer of 1985. The Hudson Plant closed its doors in 1988, when it was announced that the Terex Corporation would be moving to Southaven, Mississippi. (Courtesy of Hudson Library and Historical Society.)

Originally built in 1880 by Andrew Shivley, the building seen here was Shivley's Carriage Shop, where Hudson residents could purchase horse-drawn carriages as well as have their horses fitted for shoes. In 1937, the building became a Chevrolet dealership then an auto repair shop. In 1979, a bank moved in, and the building continues to house a bank to this day. (Courtesy of Hudson Library and Historical Society.)

The Learned Owl Book Shop, seen here in this photograph from the 1980s, first opened in 1968 in what is now known as the Children's Room. Independently owned and operated, the Learned Owl has played host to a wide variety of author visits and signings, including from illustrator Eric Carle and former Cleveland Indian Bob Feller. (Courtesy of Hudson Library and Historical Society.)

The two-story brick building on the corner of Main Street and Aurora Street was constructed as a dry-goods store for local merchant Anson A. Brewster. The Brewster family owned many of the buildings on this small section of Aurora Street, including the Brewster Mansion next door, which is where Anson lived. (Courtesy of Hudson Library and Historical Society.)

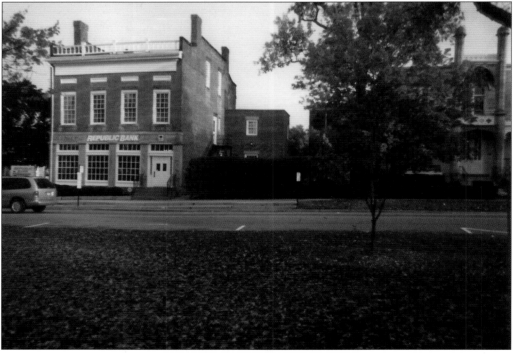

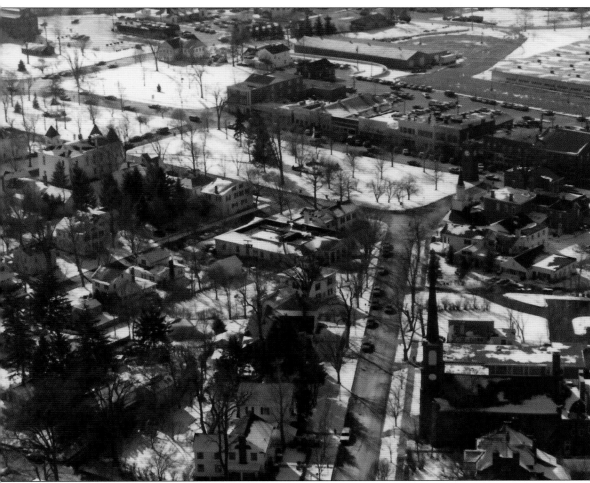

In the top right corner of this aerial view of Hudson is the property of Morse Controls Company, which was founded in 1941 by John Morse and originally called the Morse Instrument Machine Company. In 2004, this land behind the shops on Main Street became home to First & Main and the Hudson Library and Historical Society. (Courtesy of Hudson Library and Historical Society.)

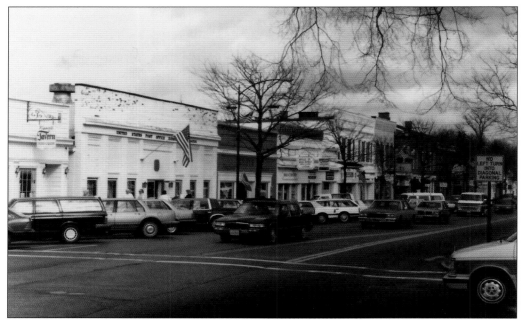

One of Hudson's more well-known features is its picturesque downtown district, and many of the buildings and businesses seen here have lined Main Street for decades. For instance, 88 North Main Street has been a restaurant or bar since the 19th century, beginning in 1892 when A.W. Lockhart used insurance money to rebuild his Lockhart's Saloon after a fire that originated there devastated Main Street. In 1919, the building was sold to the Kepner family, and Kepner's Tavern opened soon after. Next door, the Gap is at 86 North Main Street, which previously was the Hudson Post Office and before that a bowling alley and arcade. (Both, courtesy of Hudson Library and Historical Society.)

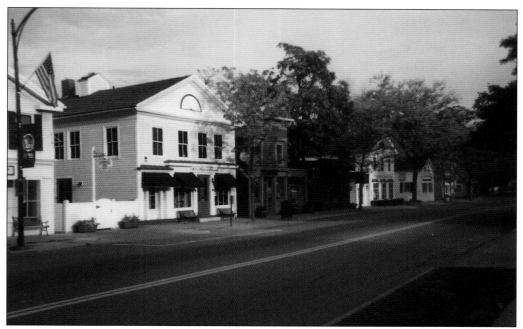

The white building located at 200 North Main Street was constructed in 1834 for local merchant John B. Whedon. In recent years, it operated as a bar and restaurant known as the Old Whedon Grille, presumably named for the original owner, and currently it is home to a Southern-cooking-style restaurant. (Courtesy of Hudson Library and Historical Society.)

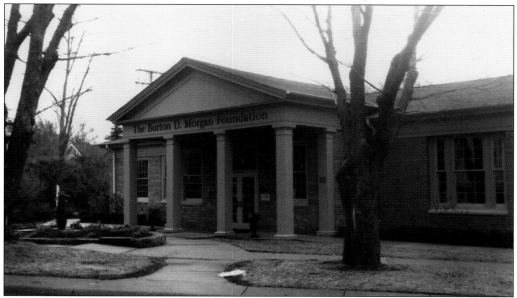

Local philanthropist Burton D. Morgan spent the later years of his life encouraging his foundation to make its home in downtown Hudson near the iconic Green. When the Baldwin House became available in 1999, the foundation was able to buy it from the Hudson Library and Historical Society and in 2002 bought the adjacent Babcock House, finally moving into its current home in 2006. (Author's collection.)

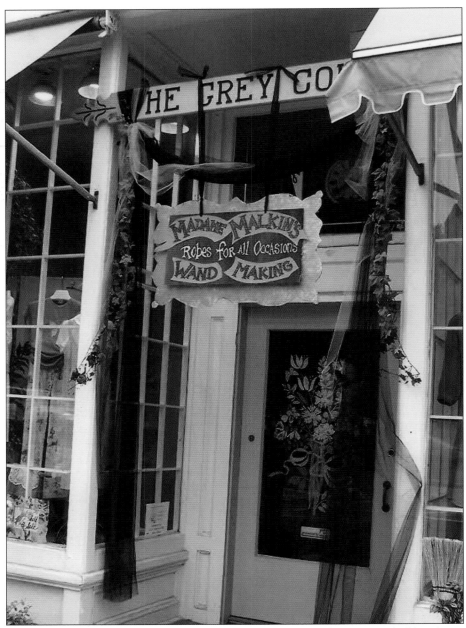

In honor of the release of the seventh Harry Potter book, a citywide party was held in downtown Hudson, and shops were magically transformed into locations from the series. The Grey Colt, a women's fashion boutique, took on the identity of a wizard's robe shop. Taking its name from original owners Pris and Ash Graham and Patty and Stewart Coulton, the Grey Colt opened in 1959 and was initially located in one of the upper-level spaces on Main Street. In 1962, the shop moved down the block to a space next to Saywell's, which is where it has been ever since. Patty Coulton, one of the founding owners, worked at the Grey Colt until 1999. Her daughter Katie first started helping out at the store in the 1970s when she was in the fourth grade, and she is the Grey Colt's current owner. (Courtesy of Jennifer Coppolo Holsing.)

For nearly a century, Saywell's Drug Store was a fixture of Hudson's picturesque downtown before it shut its doors in 2005. Built in 1909, it had been a Hudson icon longer than the clock tower and, fictionalized as Maywell's, is the setting of Cynthia Rylant's picture-poetry book *Soda Jerk*. (Courtesy of Liz Murphy.)

Merino's Beer and Wine first opened in 1946 under the ownership of World War II Navy veteran and lifelong Hudson resident Rich Merino and his father, Gaetano "Charles" Merino. When First & Main opened, Merino's relocated from this building to another site in the shopping plaza before permanently closing in 2014. (Courtesy of Hudson Library and Historical Society.)

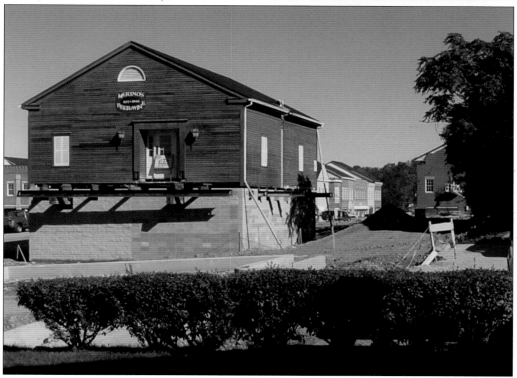

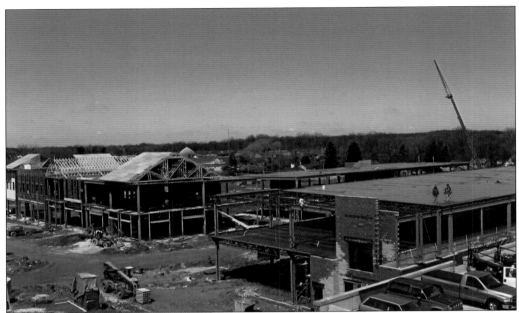

The historic Main Street shopping district was expanded in 2004 with the addition of the 200,000-square-foot mixed-retail space First & Main. Built on property once owned by Morse Controls Company, the facades were designed to aesthetically match the historic buildings on Main Street. (Courtesy of Fairmount Properties.)

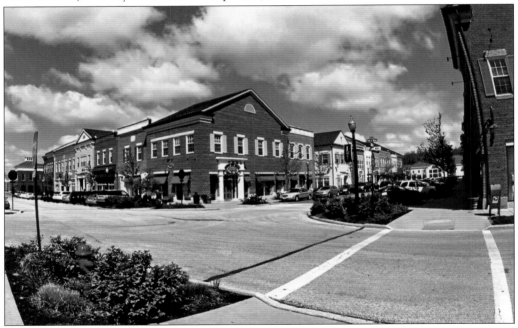

The collection of shops and restaurants that make up First & Main includes national stores as well as locally owned boutiques and award-winning restaurants. With multiple green spaces throughout the complex, First & Main also plays host to various cultural events throughout the year, including the annual Taste of Hudson. (Courtesy of Tori Tedesco Design & Photography.)

Three

HISTORIC HOMES

Built in 1833 by architect Leander Starr, this North Main Street home's most prominent owner was abolitionist Judge Van R. Humphrey. In 2009, the Hudson Heritage Association selected the Humphrey House for its annual holiday tour. Local merchants decked the home's halls in seasonal finery, and tea was served each day. (Courtesy of Hudson Library and Historical Society.)

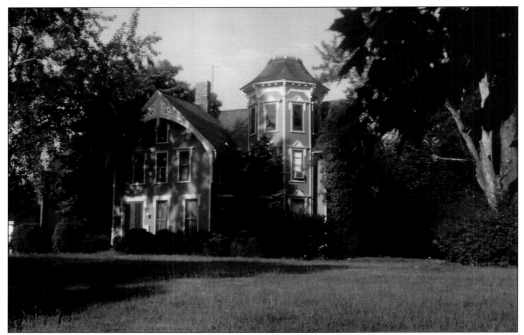

Built in the Queen Anne style, this home just south of the downtown district dates back to 1882. In January 2000, there was a fire in the home, but most of the damage was contained to the front portion of the house. In rebuilding, the homeowners were dedicated to preserving the original look of the home as much as possible. (Courtesy of Hudson Library and Historical Society.)

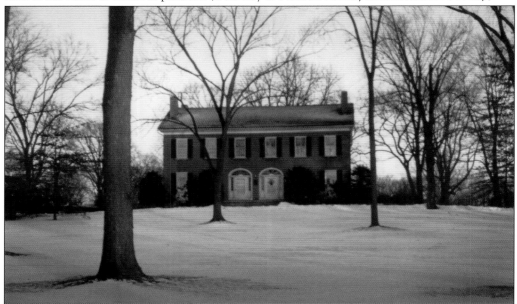

The President's House was one of the first buildings built on the Western Reserve Academy campus and is now the oldest building still standing. Added to the Historic American Buildings Survey in the 1930s, the President's House is now home to two faculty families. (Courtesy of Hudson Library and Historical Society.)

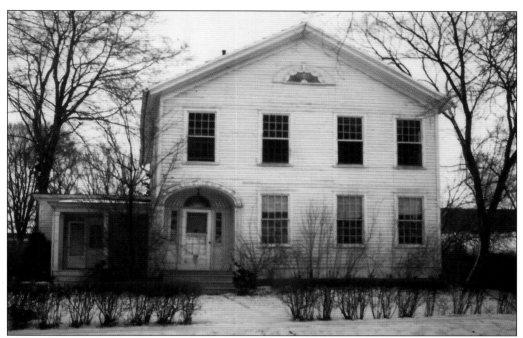

No. 79 Hudson Street was built in 1831 for Rufus Nutting. Along with being a professor at (then) Western Reserve College, he was also the college librarian and first superintendent of the Sunday school at the Congregational church. In 1840, when Western Reserve College stopped providing free tuition to the sons of its faculty members, the Nuttings left Hudson and moved to Michigan. While there, Rufus founded the Romeo branch of the University of Michigan. Today, the Nutting-Farrar House is one of many homes on the campus used by Western Reserve Academy for faculty housing. (Both, courtesy of Hudson Library and Historical Society.)

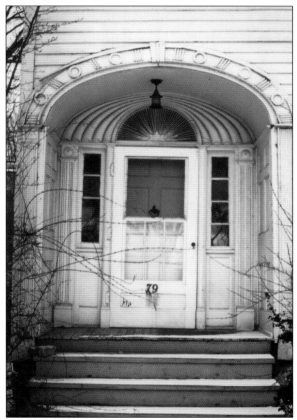

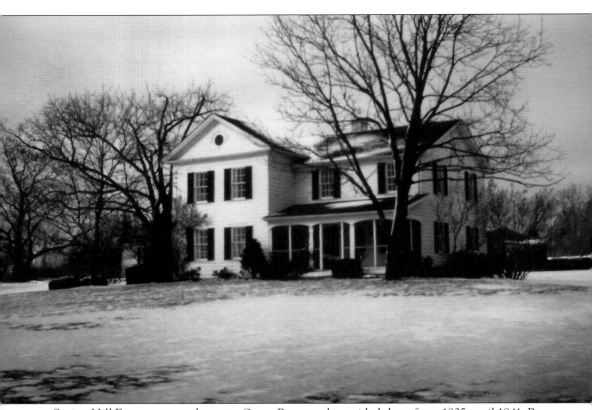

Spring Hill Farm was once home to Owen Brown, who resided there from 1835 until 1841. Brown was a staunch abolitionist and established Hudson's Free Congregational Church. He was heavily involved in Hudson's Underground Railroad, and his son John Brown led the raid on Harpers Ferry in 1859. (Courtesy of Hudson Library and Historical Society)

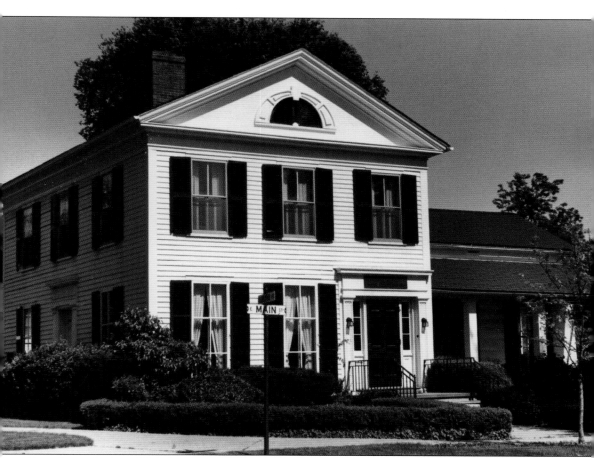

Since being built in 1834, the Baldwin-Babcock House has served many purposes within the city, including being the former location for the Hudson Library and Historical Society. The library was founded by Caroline Baldwin Babcock, who had previously lived in the house. Today, it provides office space for multiple community organizations. (Courtesy of Hudson Library and Historical Society.)

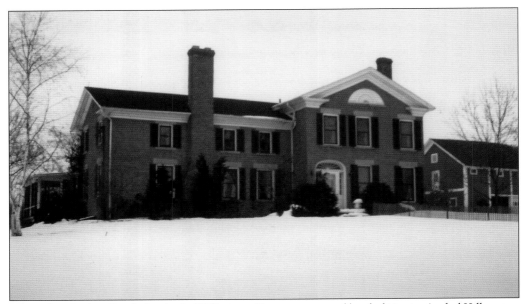

Located on Barlow Road, the Asahel Kilbourne House was owned by abolitionist Asahel Kilbourne, a member of the Free Congregational Church. His antislavery views were well known, and his name appears on the Historic Underground Railroad Marker in the center of town. (Courtesy of Hudson Library and Historical Society.)

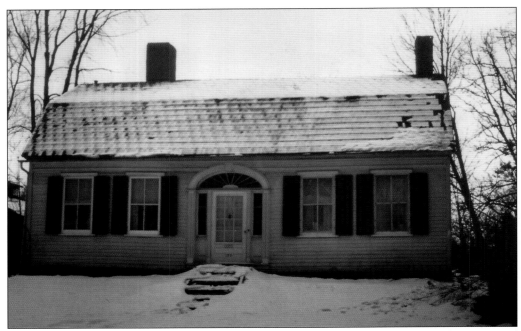

Elizur Wright Jr. lived in this home on Hudson Street while he was a mathematics and natural philosophy professor at Western Reserve College. One of the original founders of the American Anti-Slavery Society, Wright also edited multiple abolitionist texts, including *Human Rights* and *Quarterly Anti-Slavery Magazine*. (Courtesy of Hudson Library and Historical Society.)

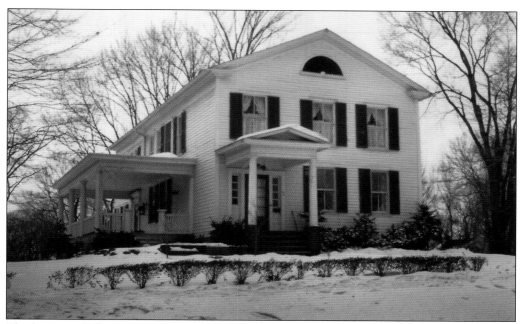

This house on College Street was once the home of Rev. Harvey Coe. While not a known abolitionist, Reverend Coe was a member of the American Colonization Society, an organization that supported abolition in so far as believing that African Americans would have greater opportunities back in their home continent of Africa. (Courtesy of Hudson Library and Historical Society.)

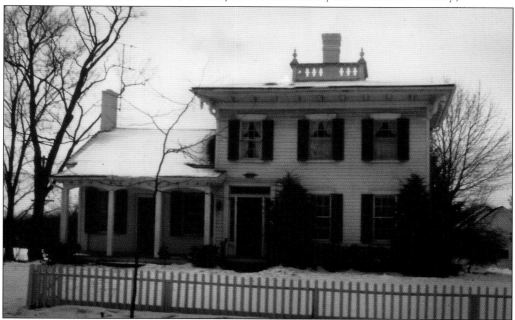

Built in the Greek Revival style, the Waite Home catered to several generations of the Waite family, including Frederick, who was the founder of the Department of Histology and Embryology at Western Reserve University Medical & Dental Schools. Former Hudson mayor Arthur Waite also spent his childhood here. (Courtesy of Hudson Library and Historical Society.)

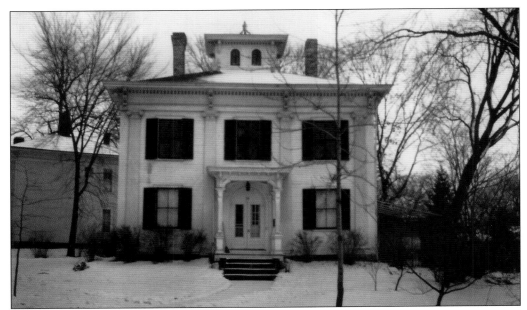

Built in 1826, the Whedon-Farwell House is one of Hudson's oldest homes and boasts the unique feature of being built facing directly west. Original owner Benjamin Whedon was a deacon at the Congregational church, but he was excommunicated after it was discovered dances had been held in his home. After Charles Farwell moved into the house in 1850, six generations of Farwells called it home. (Courtesy of Hudson Library and Historical Society.)

Built in 1852, the Potwin Cottage was named after former resident Lemuel Stoughton Potwin, who was once a Latin professor at Western Reserve College. In 2010, the home went through a major renovation and is currently used as faculty housing on the campus of Western Reserve Academy. (Courtesy of Hudson Library and Historical Society.)

This yellow Colonial Revival located on Aurora Street was built during the Ellsworth era and once was home to Vincent Meakin. When Meakin, a 32-degree Mason, died in 1946, he left one-third of his estate to the Masonic building fund, which made it possible for the Masons to buy their present temple on Streetsboro Street. (Courtesy of the Hudson Library and Historical Society.)

The building on the corner of East Main and Division Streets has always been home to a business. Built in 1841 for Edgar Birge Ellsworth, who was the father of James W. Ellsworth, the structure originally held a merchant business. Since then it has been a bakery, an antiques shop, a photography studio, and more recently, a dentist's office. (Courtesy of Hudson Library and Historical Society.)

On the north end of town sit the Henry Wehner House (left) and the Strong House (right). Wehner owned a dry-goods store on Main Street that was destroyed during the fire of 1892, and Mary Strong founded the Hudson Female Seminary in her home in 1846. (Courtesy of Hudson Library and Historical Society.)

The many red-tile roofs visible throughout Hudson date back to the James W. Ellsworth era. As part of his community-wide restoration process he offered the distinctive tiles free of charge to anyone willing to reroof his or her home. Many of these homes are also painted white, as Ellsworth also provided white paint at no cost. (Courtesy of the Clay Herrick Collection at Cleveland State University Library.)

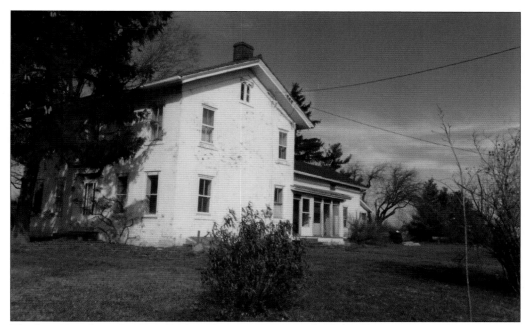

The homestead on the Case-Barlow Farm property was built by Chauncey Case between 1826 and 1831 using brick handmade on the property and fired in Case's own kilns. Five generations of Chauncey's descendants have lived in the home, including his granddaughter Hattie, who married Franklin F. Barlow, a hired hand. After Hattie's father, Henry, died, she returned to the property with her husband, and the Case-Barlow family took over the farm. Today, the farmhouse is the site of many events throughout the year, including the Fall Harvest Fest and an annual dollhouse exhibition. (Both, courtesy of Case-Barlow Farm.)

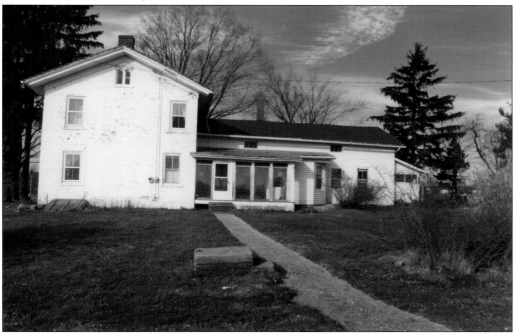

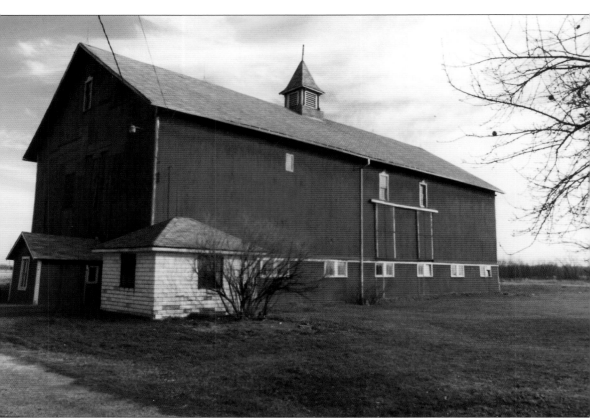

The Case-Barlow Farm operated under five generations of the family, starting with Chauncey Case in 1814 and ending in 1995 with Donald C. Barlow, who took over the farm in 1941. At one point, the property was comprised of over 418 acres, which included land on the other side of the road. In 1957, Barlow sold the land south of the road to General Motors. That land, combined with the property that was once Mid-City Airport, became the General Motors Euclid Plant. Along with the barn, other buildings that once stood on the farm include a sugarhouse, smokehouse, privy, and chicken coop. The road right in front of the farm was originally called Kent Road, but Summit County decided to honor the family in 1947 by renaming it Barlow Road. (Courtesy of Case-Barlow Farm.)

Case-Barlow Farm has operated as a nonprofit since 1996, and one of the organization's missions is to restore the barn with the intention of eventually making it available to rent for events. During the Civil War, Case-Barlow Farm was a known stop on the Underground Railroad, and tradition says the slaves hid in the nearby woods. In the early 1990s, the homestead was donated by the Barlow family to the First Congregational Church, which later sold it to a nonprofit organization that aims to restore and preserve the farm. (Both, courtesy of Case-Barlow Farm.)

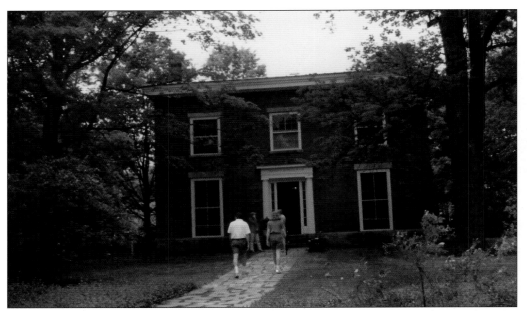

The Nathan Seymour house, which is located on the Western Reserve Academy campus, is named after the Western Reserve College classics professor who built the home in 1843. The academy acquired the building in 1994, and today it is used as the campus guesthouse. (Courtesy of Jimmy Sutphin.)

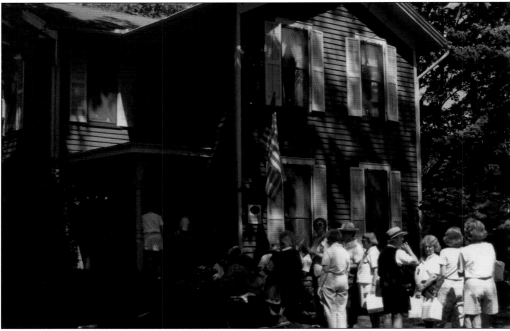

Hudson residents gather outside this home on Oviatt Street as part of the Hudson Home and Garden Tour. Hosted by the garden club every June, the event gives the 1,250 people who attend an opportunity to tour the many historic homes and gorgeous gardens within the community. (Courtesy of Jimmy Sutphin.)

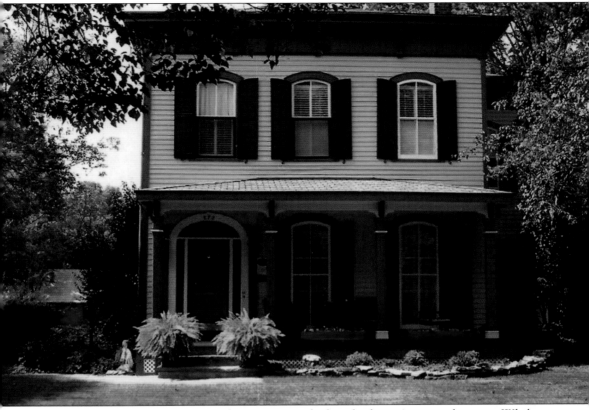

Built in 1873, the Jeremiah B. King home is named after the house's original owner. While the home originally had a front porch, it is presumed to have been removed during the Great Depression after falling into disrepair. The curved front shutters were also removed at some point, and when the current owners purchased the house in 2001, they found the shutters in the barn and put them back on. In 2002, the home opened as a bed-and-breakfast, and the grand front porch was painstakingly restored in 2006, using historical photographs that are on display in the home. (Courtesy of the Jeremiah B. King Guest House.)

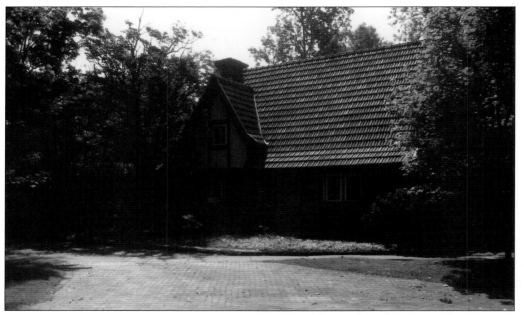

Located on the corner where Hudson Street and Aurora Street combine into Hudson-Aurora, this Tudor Revival was built as the gatehouse of James W. Ellworth's country estate, Evamere. Named after his late wife, Eva Butler Ellsworth, the land on which Evamere was built was once the site of the Ellsworth family farm, modeled after an English country estate. The estate was razed in the 1950s, and only the gatehouse and part of the stone wall survive. Today, the land is mostly owned by Hudson City Schools and is home to three elementary schools, including Evamere Elementary. (Both, courtesy of Bennett Cowie.)

Four

PEOPLE

Pictured here in August 1952 is Rev. John Walbridge of the First Congregational Church. From 1948 until his death in 1962, Reverend Walbridge was a well-loved member of the community, giving his final sermon on December 31, 1961. (Courtesy of Hudson Library and Historical Society.)

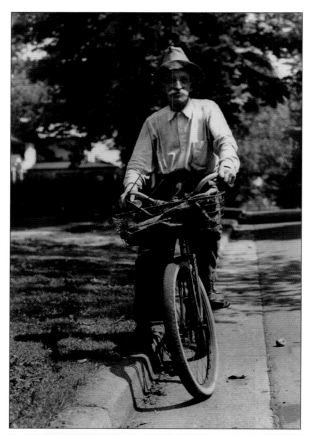

Longtime Hudson resident Eugene Rideout was the son of a Civil War veteran. Along with being a typesetter and printer, Rideout also spent many years as the custodian at the Hudson Library and Historical Society. He loved riding his bicycle around town, as evidenced in this photograph from about 1960. (Courtesy of Hudson Library and Historical Society.)

Luella Crawford Dodds (left) and Gladys Lewis are pictured here at a Hudson Players performance of *Desk Set*. The local acting organization was founded in 1945 by nine Hudson residents, including Lewis, who wanted to bring community theater back to town. (Courtesy of Hudson Library and Historical Society.)

Marie Foster Barnes, pictured here, was the daughter of H.C. Barnes, a lawyer and former mayor of Hudson. During the summer of 1899, when she was just 13, Marie kept a diary that was later published as a limited-edition book. She died in 1968. (Courtesy of Hudson Library and Historical Society.)

Born in Hudson in 1879, Luella Crawford Dodds graduated from Western Reserve Academy in 1898 and worked as the assistant to town benefactor and local millionaire James W. Ellsworth. She spent the majority of her life living at 201 North Main Street, the same home in which she was born. (Courtesy of Hudson Library and Historical Society.)

Pictured here is the 1961 Hudson High School football team. The district colors of blue and white have been in place since 1928, and over the years, the team has included many players who have gone on to play for the NFL, including Bill Nagy, Brian Winters, and Dante Lavelli. (Courtesy of Hudson Library and Historical Society.)

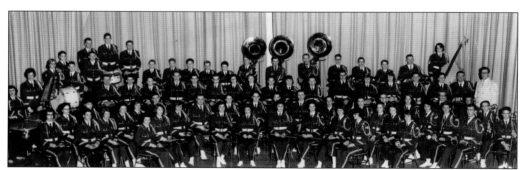

Hudson High School's concert and marching band, pictured here during the 1960–1961 season, was first established in 1935. Along with a marching band that performs during football games, the band also provides opportunities for concert bands, jazz musicians, and a wind ensemble. (Courtesy of Hudson Library and Historical Society.)

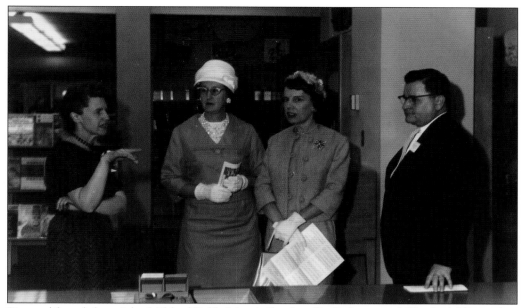

Pictured from left to right, Mildred Bubb, Marcia Sinclair, Pat Roberts, and Charles Miller gather at the event celebrating the 1963 addition to the Hudson Library and Historical Society, which added more space for reference items, the children's department, and technical services. (Courtesy of Hudson Library and Historical Society.)

An unidentified gentleman stands in the middle of Hudson's downtown square, known simply as the Green. From the beginning, the Green has often served as the location of community gatherings such as the 1906 Hudson Home Days and the 1976 bicentennial celebration, all the way to the present and the annual ice-cream social. (Courtesy of Hudson Library and Historical Society.)

In 1941, Sumner and Cora Wilhelm opened their feed store on North Main Street. Previously, the Wilhelms had owned a feed store in Portage County, but they relocated to Hudson after their original store became part of the federal arsenal in Ravenna, Ohio. (Courtesy of Hudson Library and Historical Society.)

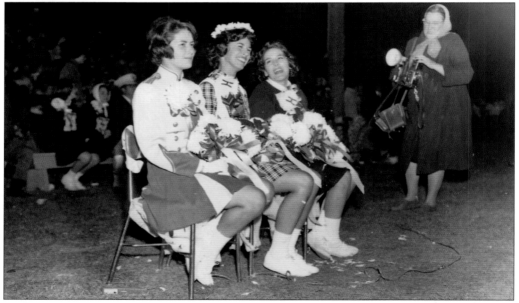

In this photograph, the 1964 homecoming court is crowned during the homecoming game while Fran Murphy, a 1940 graduate of Hudson High School, snaps a photograph. In 2013, Murphy was part of the inaugural class inducted into the Distinguished Alumni Hall of Fame. (Courtesy of Hudson Library and Historical Society.)

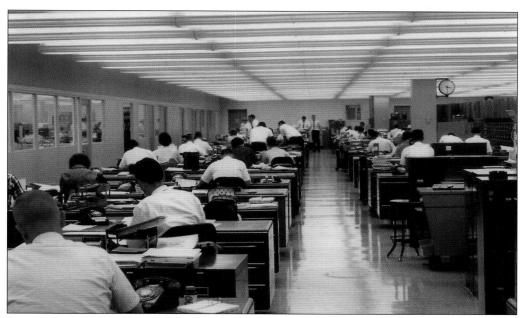

Pictured here are employees of the General Motors Terex Plant. In 1968, the justice department ruled against General Motors, forcing a four-year stop on its manufacturing off-highway trucks in the United States. GM also needed to divest the Euclid name and brand. Shortly thereafter, the Terex name was adopted. (Courtesy of Hudson Library and Historical Society.)

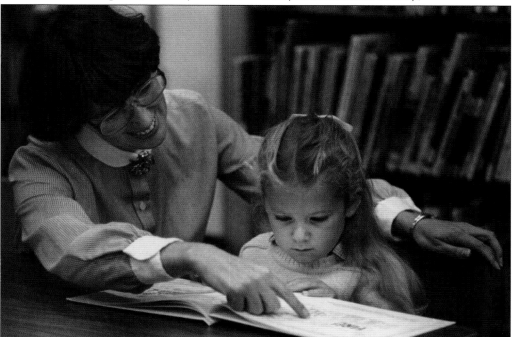

From 1970 until her retirement in August 2002, Marjie Origlio (or, as she was more often called, "Mrs. O") was a staple at the Hudson Library and Historical Society. A Hudson native, she spent three decades as the children's librarian. (Courtesy of Hudson Library and Historical Society.)

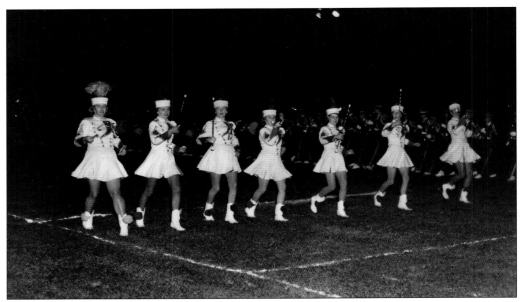

The majorettes march in front of the Hudson High School Marching Band in this photograph from the 1961 football season. These days, the marching band is accompanied by a group of band dancers who entertain the crowd by performing dances choreographed to some of the songs. (Courtesy of Hudson Library and Historical Society.)

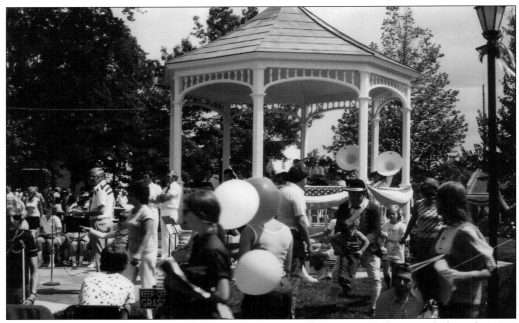

Many community-wide events are held on the Green in downtown Hudson, including the 1976 bicentennial celebration. Here, a crowd gathers around the new bandstand, which was built as part of the bicentennial commemoration. This was the third bandstand to grace the Green since 1880. (Courtesy of Patricia S. Eldredge.)

Hudson's mayor John Rogers is dressed as Uncle Sam as part of the town's bicentennial celebration in 1976. Part of the celebration for the country's first 200 years included the construction of the iconic bandstand on the downtown Green. The man at left is unidentified. (Courtesy of Patricia S. Eldredge.)

James Caccamo was the archivist at the Hudson Library and Historical Society from 1979 until his death in 2002. He was heavily involved in the local history community of Northeast Ohio and a member of multiple organizations, including Ohio Underground Railroad Association and Ohio Genealogical Association. (Courtesy of Hudson Library and Historical Society.)

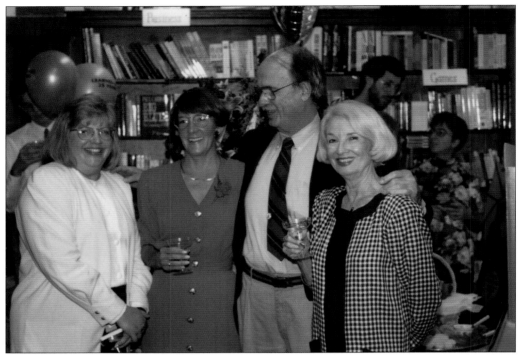

At a party held at the Learned Owl are, from left to right, Elaine Ober, Liz Murphy, Bob Isabel, and Jean Isabel. Murphy and Ober purchased the independent bookshop from the Isabels in 1983, with Murphy taking sole ownership in 1990 and managing the shop on her own before selling it in 2013. (Courtesy of Liz Murphy.)

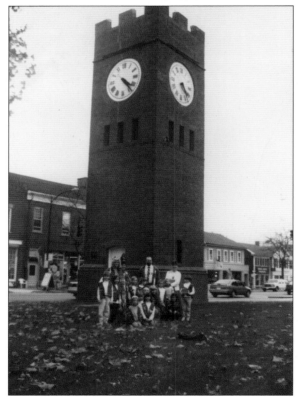

The late James Caccamo, seen here with a local Girl Scout troop in front of the clock tower, was the archivist for the Hudson Library and Historical Society. He wrote multiple books on Hudson's history and spent many years giving historical walking tours around the community, both to adults and children, a tradition maintained by his successor, Gwendolyn Mayer. (Courtesy of Hudson Library and Historical Society.)

In 1980, the Hudson Library and Historical Society introduced the Time Travelers program. Aimed at children in grades four through six, these miniature history lessons gave Hudson children an opportunity to learn about the history of the community. Here, a group of them is touring Loomis Observatory on the campus of Western Reserve Academy. (Courtesy of Hudson Library and Historical Society.)

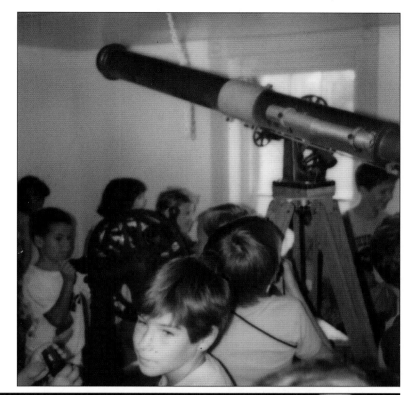

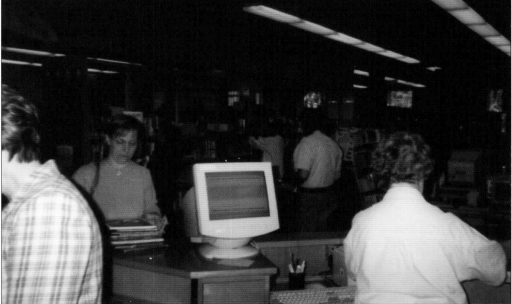

This is a 1990s view of the old Hudson Library and Historical Society from behind the circulation desk. In the 1990s, the library exceeded 300,000 circulated items for the first time in its history and also introduced the popular Tales on Tape program, which allowed children to call a number to hear a recording of a story read by a librarian. (Courtesy of Hudson Library and Historical Society.)

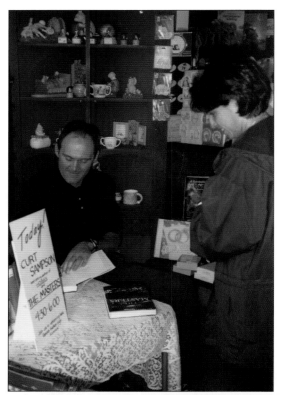

Author Curt Sampson, a Hudson native, always returned to town to do a signing at the Learned Owl with every book he wrote. A professional golf writer, Sampson began his interest in golf at Hudson's Lake Forest Country Club, where he worked as a caddie. (Courtesy of Liz Murphy.)

The Hudson High School Swing Marching Band was first established in 1935, and the group's performance is a major highlight of Hudson's annual Memorial Day parade. The uniforms seen in this 1997 photograph were first worn in 1992, and when they were retired in 2012, the 450 uniforms were turned into pillows and sold as a means of fundraising the purchase of new uniforms. (Author's collection.)

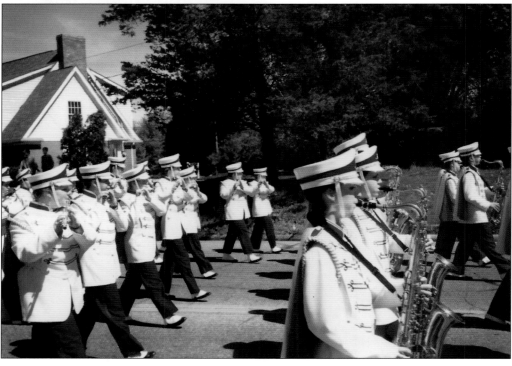

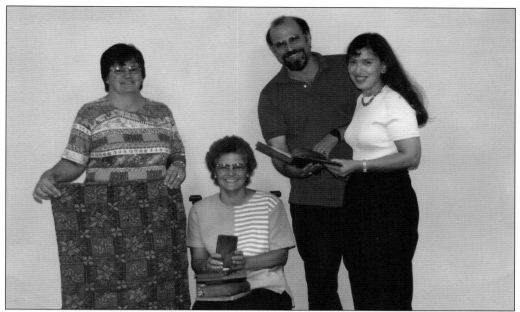

James Caccamo and E. Leslie Pollott (right), the curator and director of the Hudson Library and Historical Society, respectively, stand beside Marjorie Dingman (left) and Elizabeth Siman, two of founder David Hudson's descendants. (Courtesy of Hudson Library and Historical Society.)

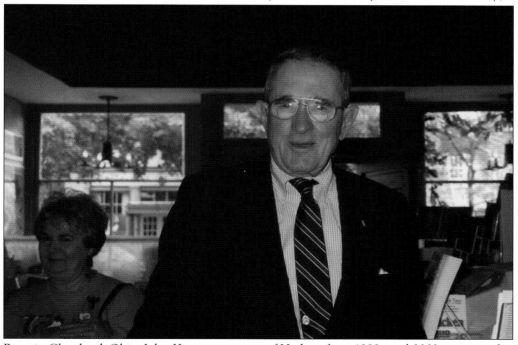

Born in Cleveland, Ohio, John Krum was mayor of Hudson from 1999 until 2003, resigning his post a few months early to take care of his ailing wife. Heavily active in the community, he also spent time on the boards of local committees as well as serving on the city council for three terms. He died in 2012 at the age of 90. (Courtesy of Liz Murphy.)

Longtime Hudson resident and local historian Tom Vince is a former director of the Hudson Library and Historical Society, past president of Hudson Heritage, and current archivist at Western Reserve Academy. In 2012, he was named Hudson's Citizen of the Year by *Good Day in Hudson*, a local cable show. (Courtesy of Liz Murphy.)

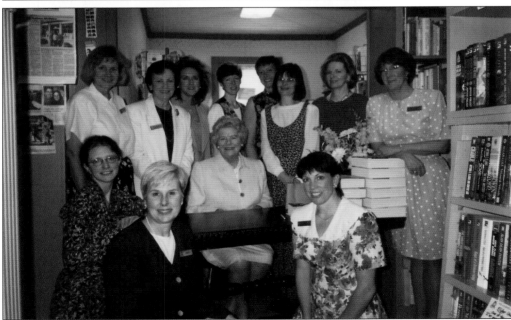

Owner Liz Murphy (far right) and unidentified employees of the Learned Owl gather around Lady Mary Soames, youngest daughter of Winston Churchill. As part of the book tour for her compilation of her parents' private letters, Lady Soames visited Hudson and the local independent bookshop for a signing. (Courtesy of Liz Murphy.)

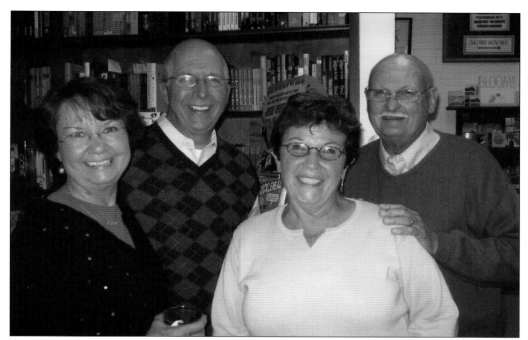

From left to right are Debbie Currin, Mayor William Currin, Linda McDonald, and Pete McDonald at a party held at the Learned Owl Book Shop. Currin has been Hudson's mayor since 2003. (Courtesy of Liz Murphy.)

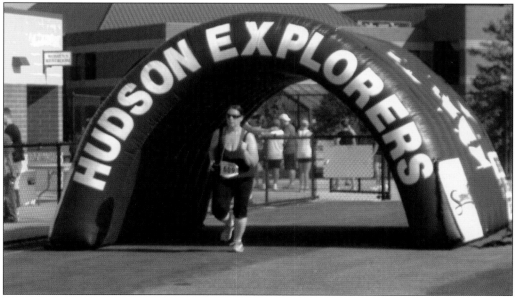

In August 2012, as part of the celebration for the brand-new Memorial Stadium, multiple community-wide events were held over the course of dedication weekend, including a 5K race, which the author participated in, as seen here. This 3.1-mile race started and ended at the new football stadium, with finishers running under the varsity football team tunnel. (Author's collection.)

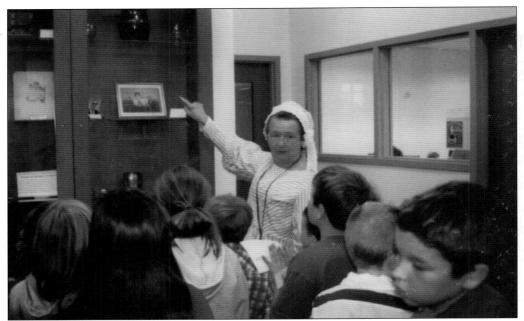

Dressed in periodic attire as Laura Pease Tallmadge Humphrey, Robin Schuricht shows third graders from Hudson City Schools some of the artifacts and photographs on display at the Hudson Library and Historical Society in this photograph from October 2006. (Courtesy of Hudson Library and Historical Society.)

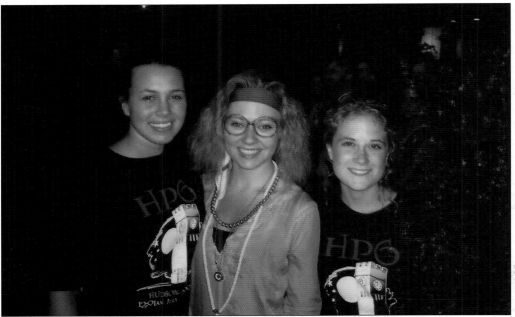

Laura Bogue (left), Jennifer Coppolo (center), and Sierra Hempl, all booksellers at the Learned Owl Book Shop, pose during the release of the sixth Harry Potter book. While Coppolo is dressed as a character from the series, Bogue and Hempl are both wearing specially designed shirts from the event that feature Hudson's iconic clock tower. (Courtesy of Jennifer Coppolo Holsing.)

Five

AROUND TOWN

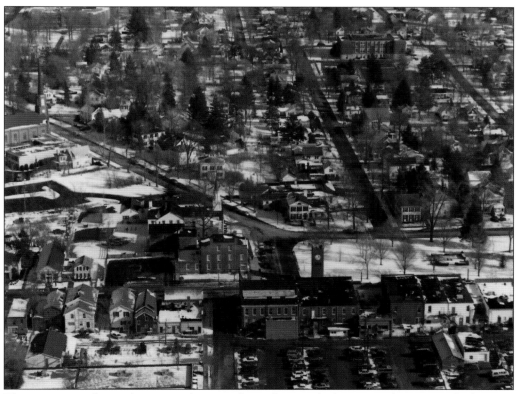

This snowy aerial view from 1989 shows Hudson's famous clock tower and Green in the bottom-right corner. On November 28, 1973, a large portion of the village was listed as the Hudson Historic District by the National Register of Historic Places. In the fall of 1989, the district was expanded to include a few more streets. (Courtesy of Hudson Library and Historical Society.)

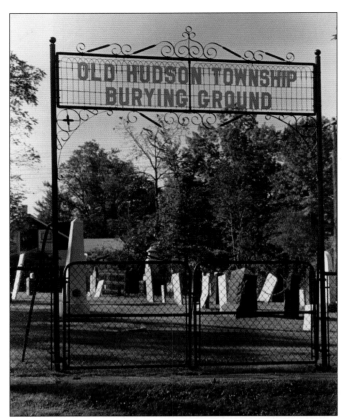

This gate marks the entrance to the Old Hudson Township Burying Ground, located on Chapel Street. It is the final resting place of about 80 individuals, including several Revolutionary War veterans and the parents of abolitionist John Brown. (Courtesy of Hudson Library and Historical Society.)

Visible on the far left is the original location of Hudson's Acme Fresh Market Grocery Store, a local chain that has been in business for over 120 years. Hudson was the fourth location for the grocery store, and it was at this location until 1962, when it moved to its current spot as part of the Hudson Plaza. (Courtesy of Hudson Library and Historical Society.)

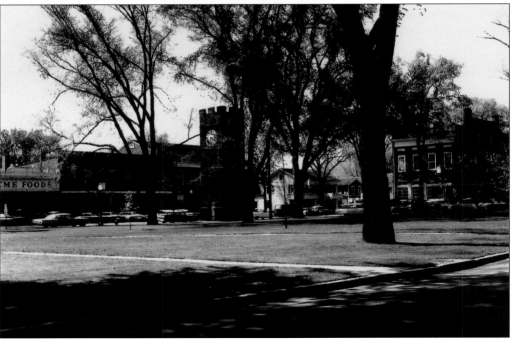

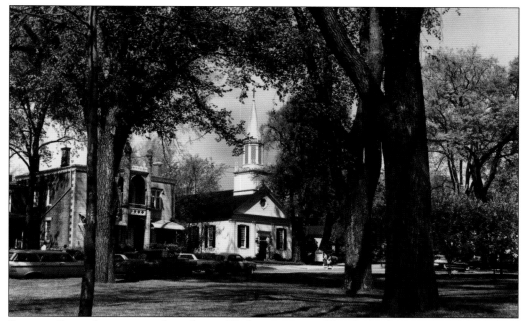

Brewster Row takes its name from former Hudson mayor and local merchant Anson A. Brewster, who lived in the Gothic Revival Brewster Mansion (left) and owned many of the buildings on the street. Next door is Christ Church Episcopal, a denomination that Anson A. Brewster was instrumental in bringing to Hudson. (Courtesy of Hudson Library and Historical Society.)

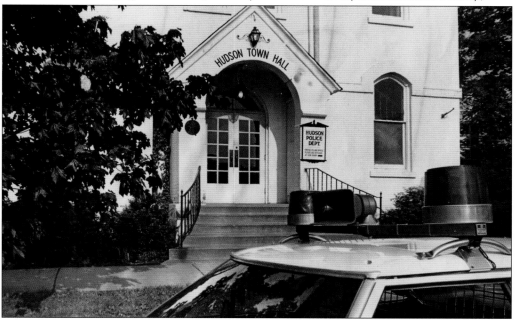

Located at 27 East Main Street, the Hudson Town Hall is the center of the city's government and administration. The facility, which dates back to 1879, features a meeting room which is utilized by city council and multiple Hudson boards for public meetings. (Courtesy of Hudson Library and Historical Society.)

Built in 1930 in the Tudor Revival style, Lake Forest Country Club was originally to be the focal point of a residential community, but only the clubhouse itself and two houses were built before the Great Depression hit and the developer fell into bankruptcy, abandoning the project. (Courtesy of Hudson Library and Historical Society.)

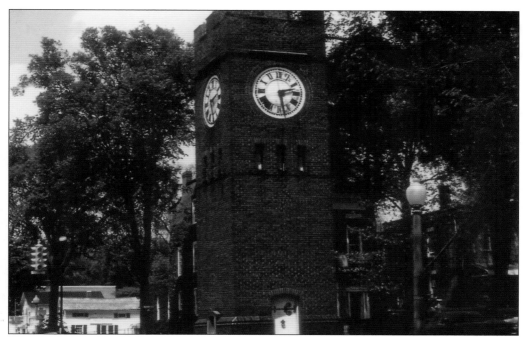

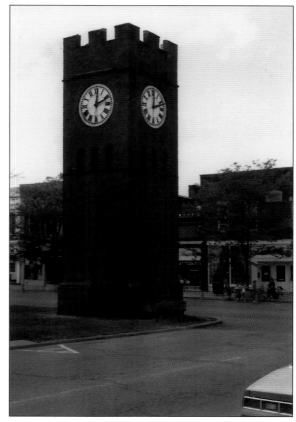

Hudson's iconic clock tower was a gift to the city from philanthropist millionaire James W. Ellsworth and dates back to 1912. Ellsworth was born in Hudson in 1849, and when he returned to the community after retiring in 1907 he found his hometown to be neglected and behind the times, with dirt streets and no city water. Much of the city was also still trying to recover from the 1892 fire that destroyed downtown, and Ellsworth made it his mission to improve the city's conditions. He also commissioned the clock tower, which originally had water fountains on its west and north sides. (Both, courtesy of Hudson Library and Historical Society.)

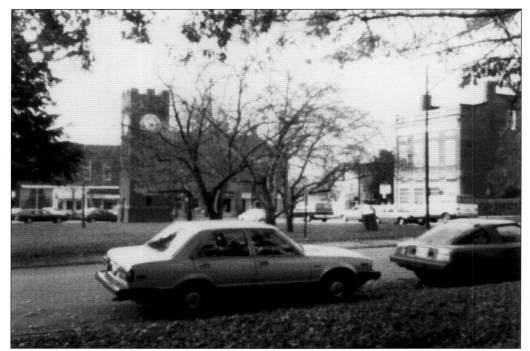

Pictured here is a view of Hudson Green and the clock tower, as seen from East Main Street, captured in front of what was at the time the Hudson Library and Historical Society. When *Cleveland* magazine named Hudson the Top Suburb, it specifically mentioned the plethora of free street parking available in the community. (Courtesy of Hudson Library and Historical Society.)

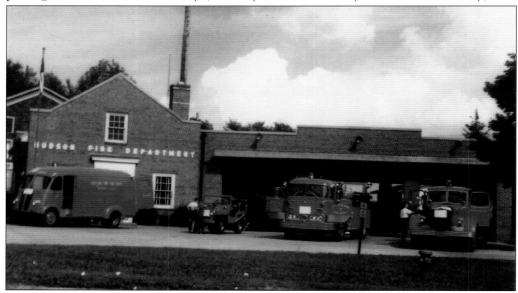

Hudson's fire department is predominantly a volunteer force comprised of Hudson residents or men and women who work in the community. Among the many services the fire department provides for the city of Hudson is Safety Town, which is an annual summer program for preschool-aged children. (Courtesy of Hudson Library and Historical Society.)

Safety Town is held every summer and aimed at children who will be entering kindergarten that fall. Utilizing toy cars, children learn about stop signs and intersections while driving around a miniature town that even features a small clock tower. In the years since this 1987 photograph, helmets have become mandatory for all students. (Author's collection.)

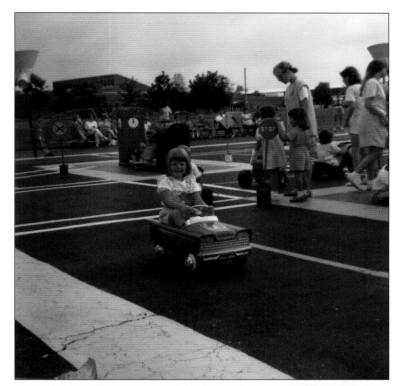

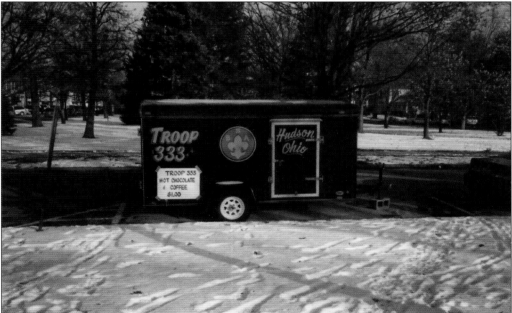

Hudson Boy Scout Troop No. 333 was chartered on February 1, 1963, and is one of many troops available to young boys within the community. The city's first Boy Scout troop, No. 321, was founded in 1917 and uses the log cabin near the Green as its headquarters. (Courtesy of Jimmy Sutphin.)

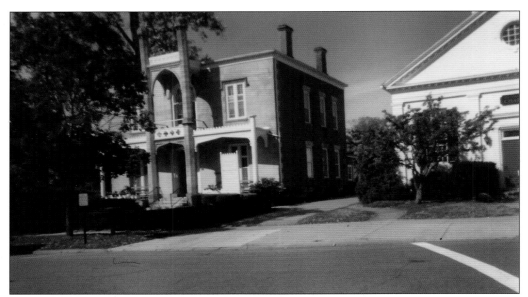

Built in 1853, Brewster Mansion was constructed on the site of John Brown's childhood home, which was destroyed by fire in 1842. The Gothic Revival castle was designed by architect Simeon Porter. Originally home to Anson A. Brewster, it was later turned into a hotel and now serves as an office building. (Courtesy of Hudson Library and Historical Society.)

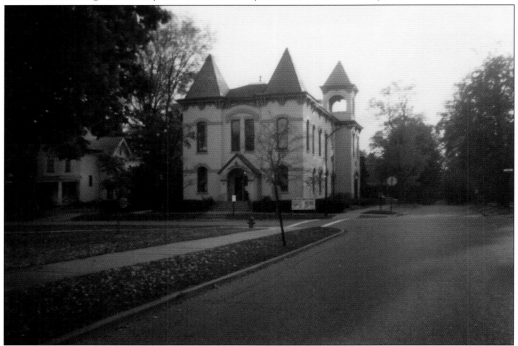

The land the Hudson Town Hall sits on was originally home to the First Congregational Church of Hudson. It was there, in 1837, that John Brown gave his first public speech denouncing slavery. The church building was removed in 1878, and the town hall was constructed in 1879. (Courtesy of Hudson Library and Historical Society.)

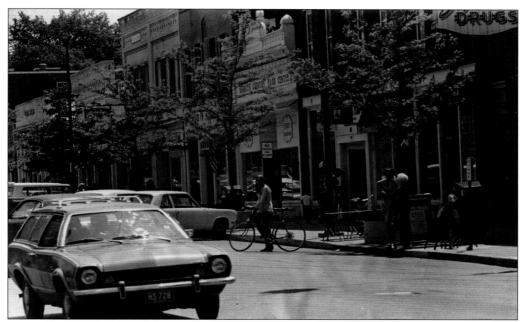

Hudson's traditional downtown has changed little over the past 200 years. When millionaire James W. Ellsworth returned to Hudson in 1907, he saw his struggling hometown as an opportunity for reinvention and poured money into the community to make it a new town, complete with electricity and running water. (Courtesy of Hudson Library and Historical Society.)

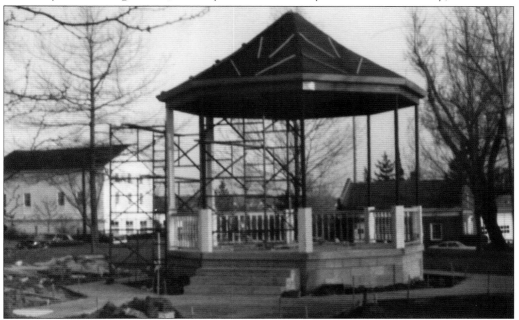

Along with the iconic clock tower, Hudson's downtown Green is also home to the bandstand, seen here during its 1976 construction. Hudson had two bandstands before this one was built. Still used to this day, the gazebo-style structure harkens back to the late 19th-century original bandstand. (Courtesy of Hudson Library and Historical Society.)

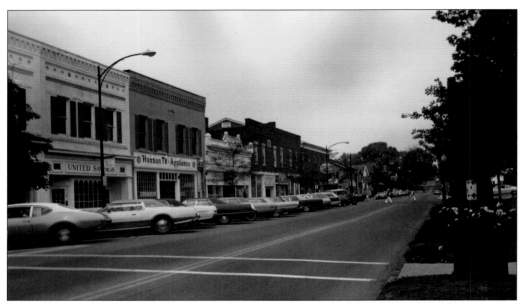

On April 28, 1892, a fire that started in the saloon at 84 Main Street swept through the attached buildings, destroying the entire downtown district, an area that is today between Park Lane and Clinton Street. This was the second fire in two years, and the town struggled through economic distress to rebuild Main Street from the ground up. Then, in 1907, native-son-turned-millionaire James W. Ellsworth returned to find his hometown on the cusp of failure. Having the resources to make an impact, Ellsworth saw this as an opportunity for reinvention and invested money into the community to outfit Hudson as a "new model town." Changes included telephone lines, paved roads, and important public services such as water, electricity, and sewers. (Above, courtesy of Hudson Library and Historical Society; below, courtesy of Steve Dulzer.)

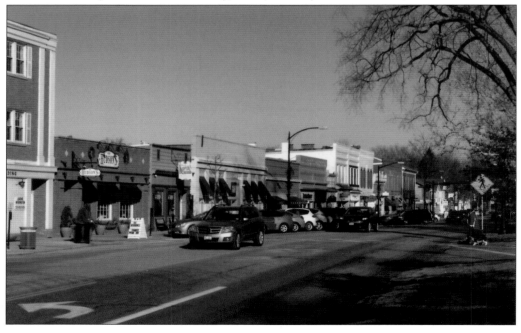

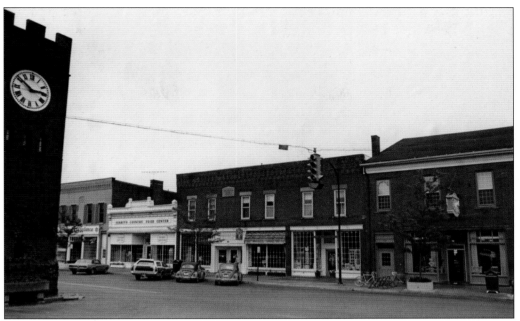

The corner of Clinton and Main Streets marks the end of the block destroyed by the infamous 1892 fire that started down the street in Kepner's Tavern. This section of Main Street in particular has been the site of many local businesses that have been around for several decades, such as the Grey Colt, which has been serving Hudson women since 1959. A few doors down is the former location of Saywell's Drug Store, which was a staple of the community from 1909 until it closed in 2005. Today, the space is home to a coffee shop. (Above, courtesy of Hudson Library and Historical Society; below, courtesy of Steve Dulzer.)

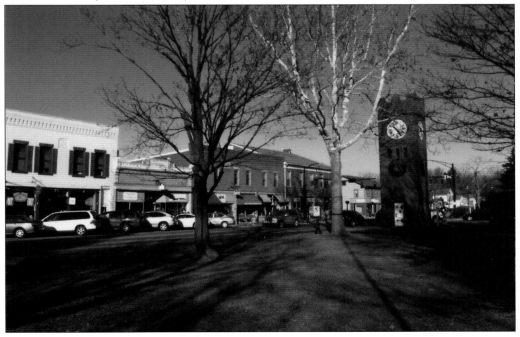

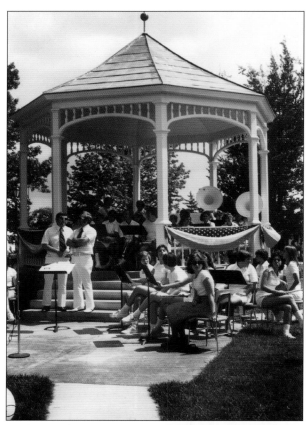

The Hudson High School band waits for its opportunity to perform on the bandstand during the bicentennial celebration, which was held on the Green downtown. Though an iconic figure now, the bandstand was still brand-new on July 4, 1976, constructed as part of the bicentennial. (Courtesy of Patricia S. Eldredge.)

As part of the 1976 bicentennial celebration, a parade was held in downtown Hudson on the Fourth of July. Here, a Terex 33-05 B Hauler dump truck takes part in the procession, appropriately outfitted in patriotic colors of red, white, and blue. (Courtesy of Hudson Library and Historical Society.)

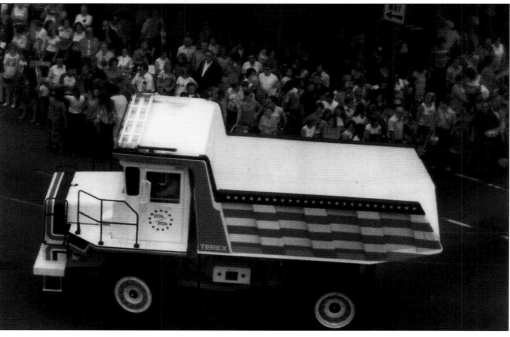

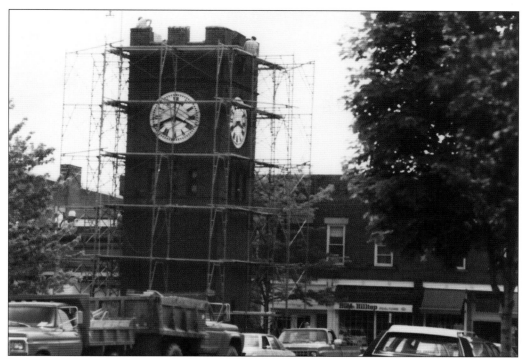

Built in 1912, the 1.5-ton weight and chimes of Hudson's iconic clock tower originally needed to be wound by hand, which town marshal Percy Dresser did from 1935 to 1950. Electric power was eventually added, and a 2001 renovation took place to keep the clock in good working order. (Courtesy of Hudson Library and Historical Society.)

The center of Hudson is marked by the intersection of State Routes 303 and 91, seen here looking south at 91. Downtown, the streets are known as Streetsboro and Main Streets, respectively. While Route 91 runs north-south between Twinsburg and Stow, Route 303 runs west-east between the cities of Boston Heights and Streetsboro, hence its common name. (Courtesy of Hudson Library and Historical Society.)

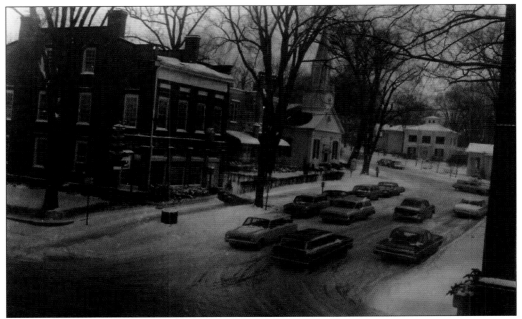

Brewster Row, so named for merchant Anson A. Brewster, who owned most of the buildings on the block, is comprised by of what was the Brewster Store on the corner, the family home, Brewster Mansion, and the Episcopal church at the end. The historic Whedon-Farwell house can be seen in the background. (Courtesy of Hudson Library and Historical Society.)

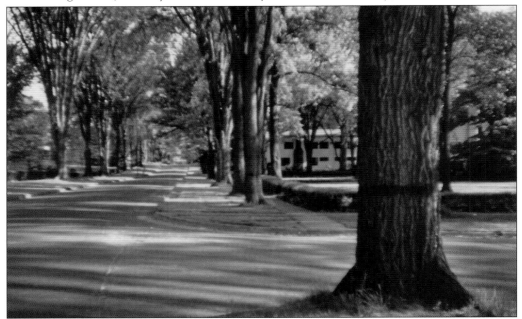

The line of trees seems to stretch into forever in this photograph of Aurora Street. Many of the streets in Hudson are named after the border cities each road connects to, including Aurora, Streetsboro, and Stow. Up until 1947, Barlow Road was Kent Road. (Courtesy of Hudson Library and Historical Society.)

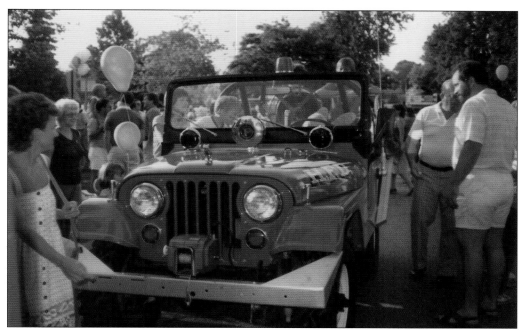

Held every summer on the Green, the annual ice-cream social is hosted by the Hudson League of Service and dates back to 1947, the same year the league was founded. Along with eating ice cream, other activities provided for residents include cake walks, face painting, and tours of some of the city's emergency vehicles, such as the bright-red Jeep owned by the fire department that was present at the 1984 event. All money raised goes toward the Hudson League of Service's grant and scholarship program. (Both, courtesy of Hudson Library and Historical Society.)

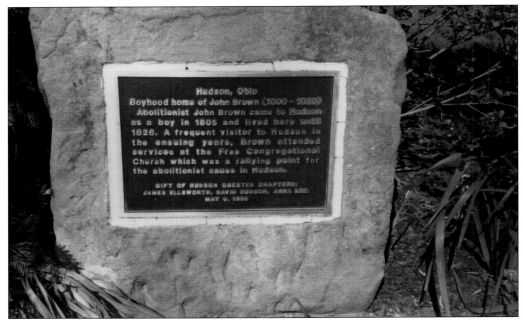

This plaque commemorating abolitionist John Brown was dedicated on May 9, 1985, and is located in downtown Hudson. Born in Connecticut in 1800, Brown moved with his family to Hudson in 1805, where his father, Owen, opened a tannery. A staunch abolitionist, Owen Brown went on to found the Free Congregational Church. John spent much of his early years in Hudson and surrounding communities before his famous raid on Harpers Ferry. The plaque was the gift to the city by the three local Quester chapters. This international organization promotes education and preservation of historic sites. (Both, courtesy of Hudson Library and Historical Society.)

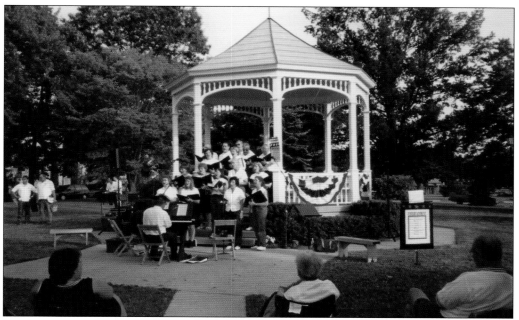

Sunday evenings during the summer, the Green plays host to musical performances of many genres, including jazz, orchestra, and brass. Founded in 1977, the Summer Music Festival is a nonprofit organization funded entirely through private donations from sponsors and individual donors. While chairs are provided, the audience often will dance in the streets. Many of the performers are locals, such as the musicians who make up the Hudson High School Marching Band and the Western Reserve Community Band, but acts from all over Ohio also have graced the bandstand stage. (Both, courtesy of Jimmy Sutphin.)

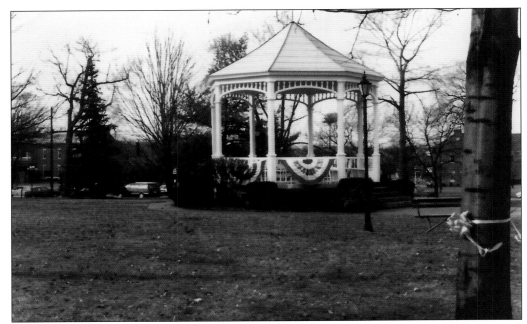

The patriotic decorations seen here on the Hudson Bandstand provide a hint to its history and heritage, as the bandstand was built in 1976 as part of the bicentennial of the United States. The roof is copper, and it is one of Hudson's most recognized icons, along with the clock tower, which sits on the other side of the Green. (Courtesy of Hudson Library and Historical Society.)

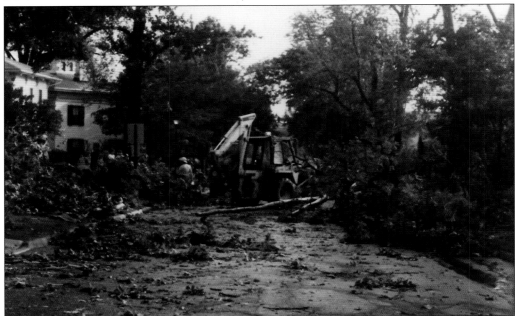

On May 31, 1985, Northeast Ohio was hit by a record-breaking outbreak of 41 tornados. While Hudson itself was spared from any touchdowns, the severe weather still left a path of devastation, as evidence by this photograph of Aurora Street from June 1985. (Courtesy of Hudson Library and Historical Society.)

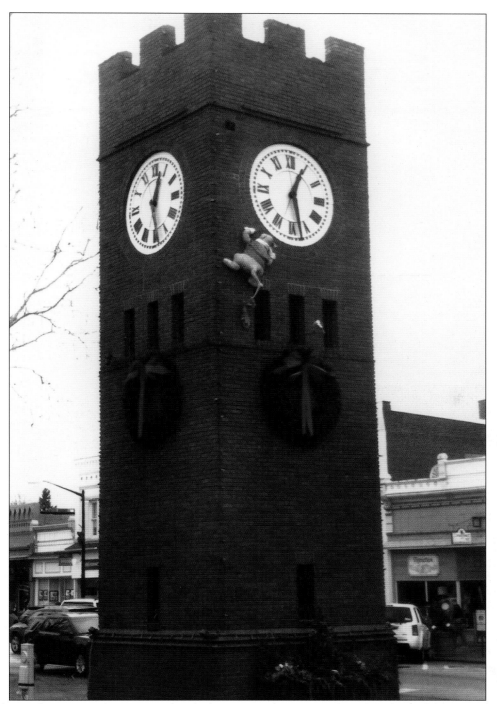

The Hudson mouse first ran up the clock tower in the winter of 1965. Fashioned from supplies donated by residents, he was made by Jeannette Wickes one weekend in her home. During the 1970s energy crisis, he was given a coat to help keep him warm. In 2000, the original mouse was replaced with the current millennium mouse. (Author's collection.)

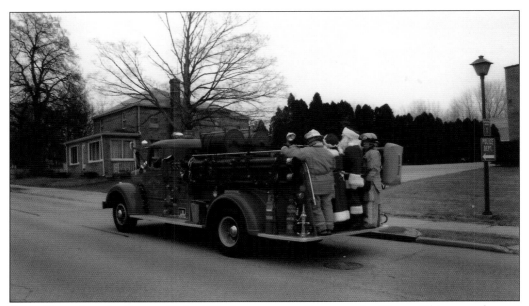

Every December, the Rotary Club of Hudson sponsors Santa on the Green. This annual event allows children from all over the area to meet Santa and Mrs. Claus, who forgo the traditional sled and arrive at the Green by fire engine thanks to the Hudson Fire Department. (Courtesy of Jimmy Sutphin.)

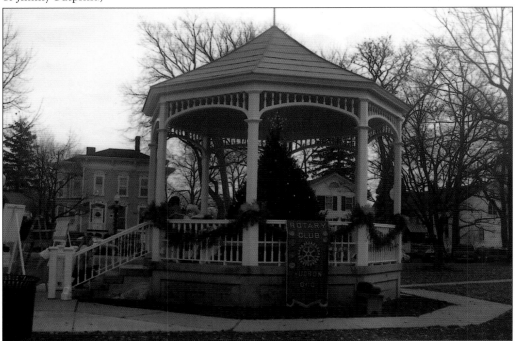

The Rotary Club of Hudson was founded in 1930, and Santa on the Green is only one of the many activities it helps organize every year. The members of the Rotary Club also assist with Art on the Green and Taste of Hudson, and they provide scholarships to local high school students. (Courtesy of Jimmy Sutphin.)

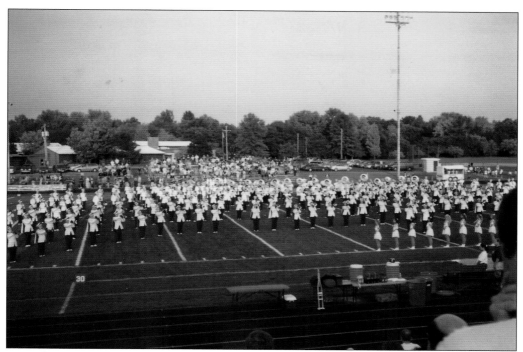

Named after a Hudson High School alumnus who went on to play for the Cleveland Browns, Dante Lavelli Field was built in the late 1950s next to what was then the Hudson High School, now a middle school. In this photograph, Evamere Elementary is seen in the background. (Author's collection.)

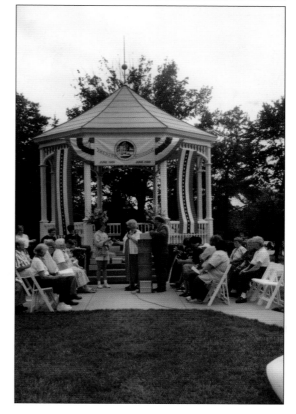

Hudson's downtown Green and bandstand have always played host to community-wide activities, including the town's bicentennial in 1999. A time capsule was buried as part of the festivities. (Courtesy of Liz Murphy.)

On a rainy day in May 2000, a crowd including Hudson Library and Historical Society director E. Leslie Polott and local archivist James Caccamo gathered on the Green for the dedication of an Ohio Historic Marker honoring Hudson's role in the Underground Railroad. Hudson was the first Northeast Ohio community to receive such a marker. The inscription on the marker makes mention of Hudson's strong ties to the abolitionist movement: founder David Hudson hid slaves at his home, and John Brown of Harpers Ferry fame spent two decades of his life in Hudson. (Both, courtesy of Hudson Library and Historical Society.)

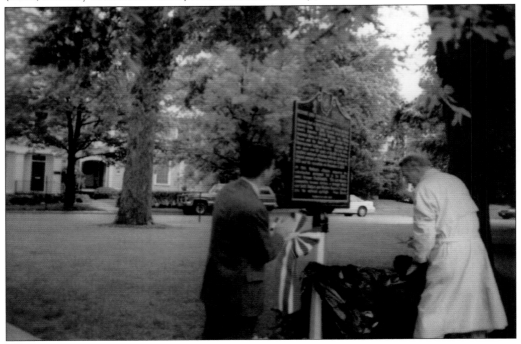

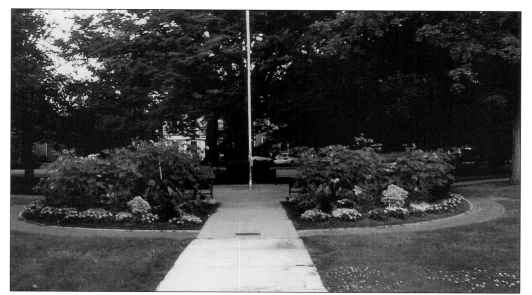

Located on the Green, Bicentennial Walkway was created in 1999 as part of the city's 200th birthday. On June 26, 1799, David Hudson and a group of surveyors arrived on the future site of Hudson, Ohio. The small settlement in Northeast Ohio was officially given the name Hudson in 1802. (Courtesy of David C. Grunenwald.)

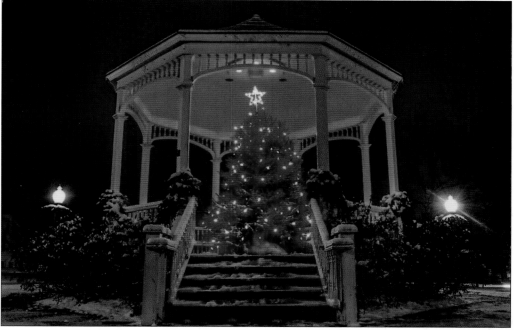

During the holiday season, Hudson's town square is adorned with over 8,000 lights. The display takes Hudson Public Power four weeks to install, all on donated time. The annual expense of the holiday lighting also comes in the form of donations from local residents and businesses. The Hudson Community Service Association has been collecting these donations since 1948. (Courtesy of Cameron Holloway Photography.)

Discover Thousands of Local History Books
Featuring Millions of Vintage Images

Arcadia Publishing, the leading local history publisher in the United States, is committed to making history accessible and meaningful through publishing books that celebrate and preserve the heritage of America's people and places.

Find more books like this at
www.arcadiapublishing.com

Search for your hometown history, your old
stomping grounds, and even your favorite sports team.